a kiss before you go

A kiss

before you go

An illustrated memoir of love and loss
by Danny Gregory

CHRONICLE BOOKS
SAN FRANCISCO

Books by Danny Gregory

Hello WORLD
Everyday Matters
Change Your Underwear
Twice a Week
The Creative License
An Illustrated Life
An Illustrated Journey

Library of Congress Cataloging-in-Publication Data available.

ISBN: 978-1-4521-0194-1

Manufactured in China.

10 9 8 7 6 5 4 3 2 1

Chronicle Books LLC
680 Second Street
San Francisco, CA 94107

www.chroniclebooks.com

I knew that there was one girl in the world who I was meant to fall in love with, one girl destined just for me, out of all the millions and billions in the world.
But what if I could never find her? What if my true love was born in Shanghai or Kalamazoo or Antarctica — and we never met? My family moved so much when I was a kid, from London to Canberra to Lahore, and I never ran into her.
Maybe she was a gypsy too and we just kept missing each other? Maybe I would never meet her, never fall in love and end up spending the rest of my life alone?

my true love at 7.

It took me a quarter of a
Century to find her.

She was trying to charge a $3 White
Russian on her corporate American
Express card. When the bartender
turned her down, I stepped in,
gallantly, cash in hand. Hours and
many White Russians later, I walked
her home.
At her door, she told me flatly we'd
never see each other again. I wasn't
her type. Not English enough, not
in a band, not cool. She wasn't
mine either — black hair, mid-
western, no Ivy League pretensions.
 And yet, impossibly, there was magic.
The next morning, I taped a big sign to
the front door of her building.
"Call me if you regain your
sense of humor."
Patti rang the next day.
 Laughing.

8

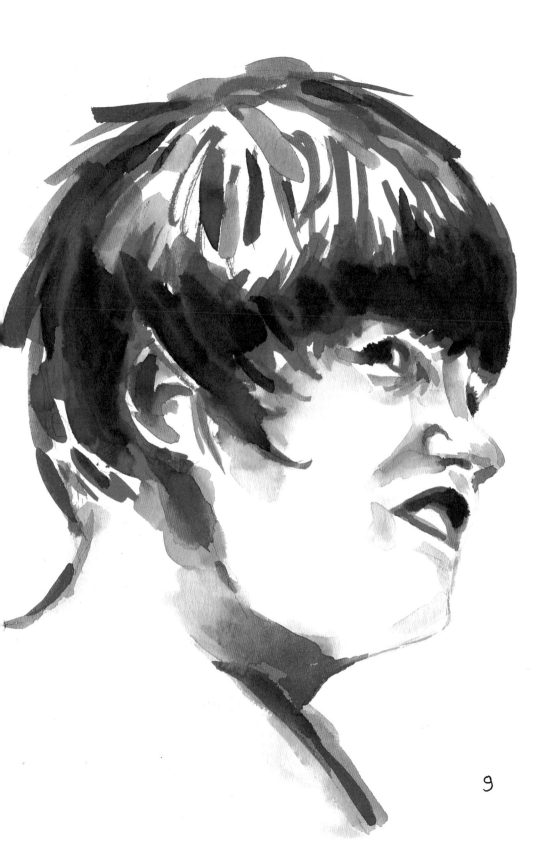

9

Five years later to the day, on June 16, we were married where we met. It was a lark, an excuse to have a big party. Our dog, Frank, was our ring bearer, We walked down the aisle to the theme from The Love Boat. Patti wore a giant FLOWER on her hat. I wore two-toned shoes.

Our next big idea: to have a baby on our anniversary. Jack arrived three weeks late, on August 10th.

After years of refusing to take things too seriously, we became parents. We tried to be a bit more grown up but not much. We sewed Jack silly clothes, we took him to parties. We gave him the middle name "TEA" after our favorite beverage. We made him the fourth member of our mini team.
GIRL, BOY, HOUND, KID.
Travelling the world, having adventures,
being creative, open, free.
FOREVER.

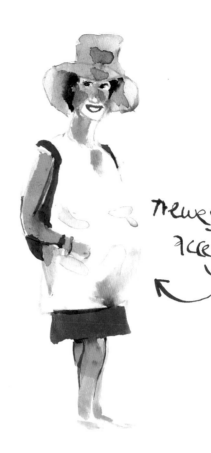

newest accessory

Then ... a week before our ninth anniversary together, the police came to my work and drove me to the hospital. Patti had slipped and fallen onto the tracks of the Christopher Street subway station. Three cars ran over her, breaking her spine, leaving her paraplegic. She would spend the rest of her life in a wheelchair.

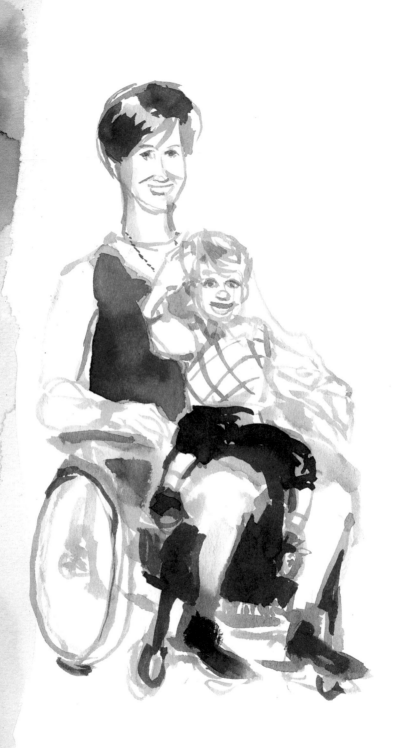

12

In an instant, the party was over, all our madcap plans erased. We were flummoxed by this new reality. No idea what it would do to our lives, to our marriage.

Jack was ten months old. He took his first steps in Patti's hospital room, holding my hand. He needed his dad. And his mom.

Months later, Patti came back home and life went on. We laughed, we teased, we cried and we wondered WHY this had happened. Each night I'd carry Patti up the stairs to our bedroom and we made plans on where we would live, what we would do, how we would carry on.

Patti couldn't push a stroller, so Jack rode on her lap everywhere she went. And she did go everywhere. We travelled to Los Angeles, Paris, London, Amsterdam, Florence, determined that, though we'd been slowed down, we would not be stopped. Patti brought the passion and enthusiasm, I was all organization and determination. We pushed on. Together.

OUR New apartment was designed so Patti could be independent. She could cook in the kitchen, work on our terrace gardens, walk Frank in the park — footloose, fancy-free.

Eventually, she quit her job to focus on looking after Jack and getting the most out of every day. "LIFE is too WONDERFUL and TIME is too SHORT," she'd tell me. "I don't want to SLOW DOWN."

Patti refused to be a good patient or to think like

a cripple.

But all too OFTEN her body was her enemy and her health had serious setbacks.

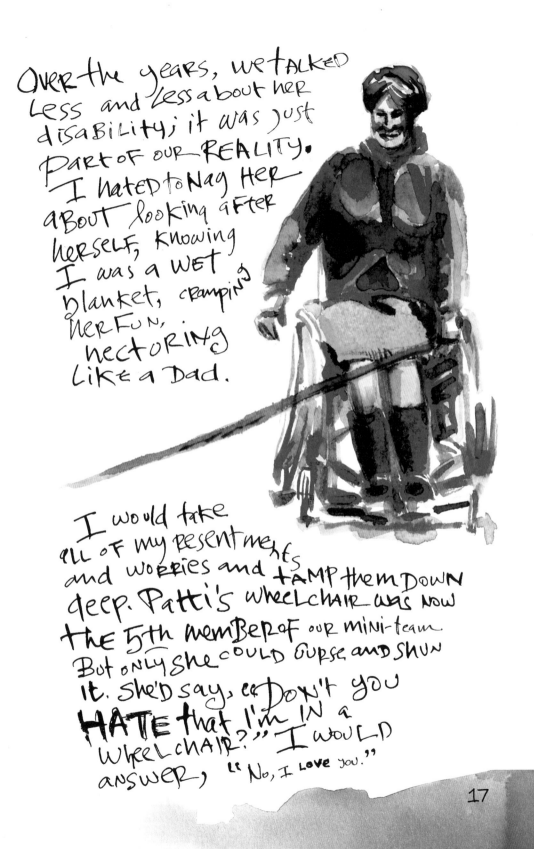

Over the years, we talked less and less about her disability; it was just part of our REALITY. I hated to Nag her about looking after herself, knowing I was a WET blanket, cramping her FuN, hectoring like a Dad.

I would take all of my resentments and worries and tamp them down deep. Patti's wheelchair was now the 5th member of our mini-team. But only she could curse and shun it. She'd say, "Don't you HATE that I'm IN a wheelchair?" I WOULD answer, "No, I LOVE you."

17

wise.

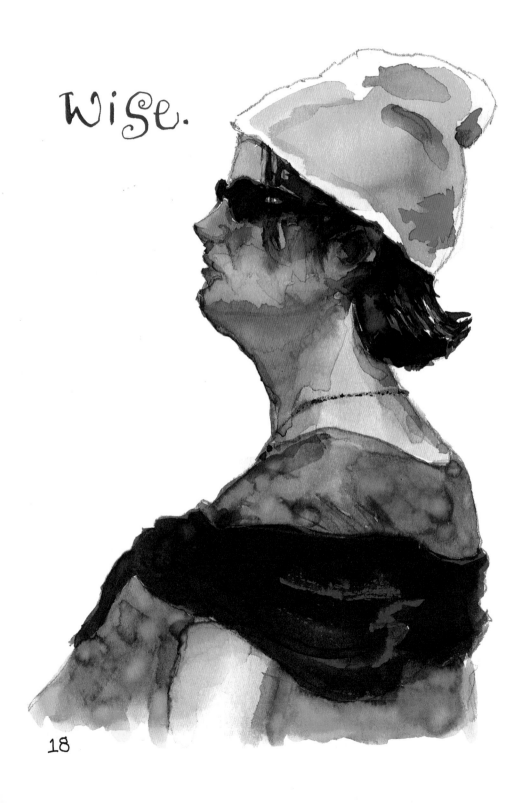

Maybe it was her disability or motherhood or maturity or karma, but over time Patti became _wise_. Wise like a sage or a village elder. People were drawn to her counsel, seeking personal, marital, health, business advice. She could find the good in anyone and empathize with any suffering.

From down in her wheelchair, she quite literally had a different perspective and spoke without ego or fear. Every night she would tell me, "I have a NEW BEST FRIEND," some random person she'd met in the street. A tourist, an artist, a vagrant.

She went where she was needed. To visit friends in the hospital, to read to toddlers in the library. She would drive her electric scooter ten miles to the Bronx to mentor a troubled teen, stopping at coffee shops along the way to recharge.

Each day she spent hours on the phone, on email, sending letters and cards around the world. Everyone knew Patti. Everyone needed her.

We vowed that we would stay together for fifty years—and not one day more. Our wedding rings were inscribed "45 to 90." On each anniversary, we would count down the years left on our sentence and joke about all we'd do once we were finally rid of each other.

One year, we calculated that 1/3 of the people who'd been at our wedding had passed away. College friends, gay friends, neighbors, grandparents. Patti's mother died, horribly, choked by lung cancer, on a hospital bed in the living room. Patti would say, "I don't want to be an old woman in a wheelchair. How gross." I didn't know what to say to such candor so I'd make jokes about the wheelchair I'd be in next to hers.

"I HAVE to DIE FIRST," she'd tell me after a couple of drinks. "I couldn't do this without you." I would try to imagine any sort of version of us old and decrepit. It was a bleary, unattractive vision, and I would put it out of my mind.

20

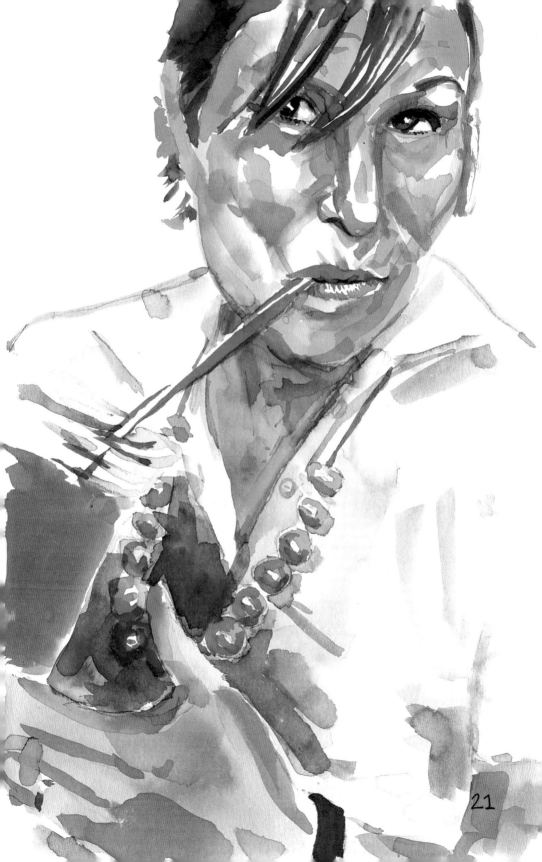

21

My 11 o'clock meeting is breaking up when my phone rings. It is a sergeant in the NYPD. She asks if I am Patricia Gregory's husband. She tells me that there has been an accident, that I need to come immediately. She refuses to answer my frantic questions, just insists I come now. Somehow, I find myself in a cab. I sit rigid in the backseat, scenarios whirling through my head. We are going to Saint Vincents hospital, the same place the police had brought me fifteen years before, the day Patti fell under the train. My first thought is that, this time, she's been run over by a bus. She's had a few traffic incidents before, zooming down the street in her scooter, dodging cabs, sailing through intersections. As we sit at a red light, I flash to her face as she lay on the gurney, in 1995, scared and scuffed with dirt from the tracks. "It'll be okay, it'll be okay," I told her over and over as I held her dirty hand. I am the only person in the hospital waiting room. Two desk clerks watch me pace back and forth, waiting for the police. My skin feels ice cold, my eyes wide, my heart racing. What has happened? What is it now? The double doors swing back to reveal doctors, nurses, cops in suits. Someone leads me into a brightly lit triage room, sits me in a chair, tells me a doctor will be with me to explain the situation in a minute. I sit straight on the stiff little chair waiting for the doctor.

The wait is brief. So brief that the thought skulking in the back of my head with me steps forward to establish itself. The other thoughts – the ones that said Patti is injured even worse this time, that she is quadriplegic, that we'll have to go through this all over again and that she will be so miserable, so limited, her life, our lives rendered unbelievably narrower – those thoughts step back into the shadow. If Patti is badly hurt, if she's broken her neck, they'd take hours to tell me the verdict. This doctor is here, empty-handed, to tell me a simpler story. I know it before the words come out in the cold white clinic; Patti has had a terrible accident. The EMTs have done all they could, the doctors have done all they could, but she hasn't made it. She is gone. I apologize to the doctor, my first instinct for inconveniencing him with this mess. My sister Miranda comes in from offstage. We hug in disbelief. A detective leads us behind a curtain to see Patti. I am taken aback to see her here, just hours after I'd kissed her goodbye and gone to work. It is midmorning and here we are. She has a tube in her mouth, her eyes are closed, her super-still body is draped in a sheet. I hold her hand and look at her. What happened? I ask her. What did you do? What is this? What do we do now?

Nothing seems real.

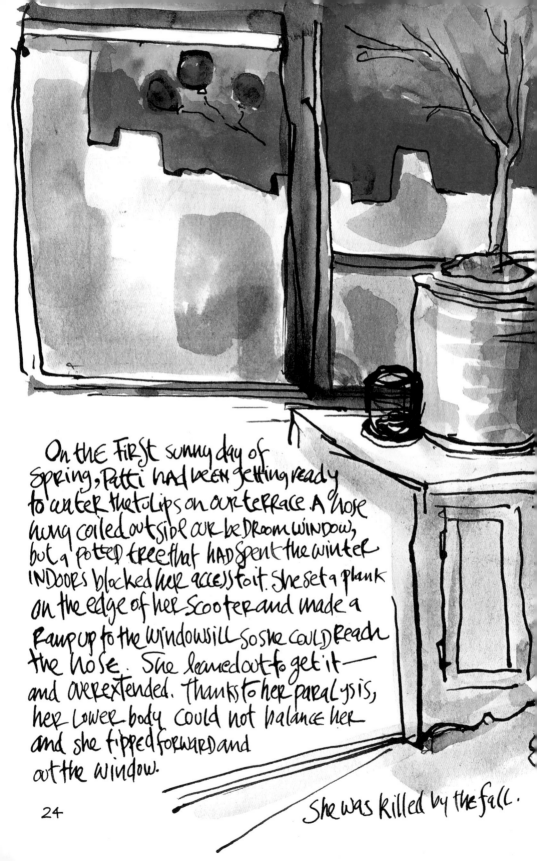

On the First sunny day of
Spring, Patti had been getting ready
to water the tulips on our terrace. A hose
hung coiled outside our bedroom window,
but a potted tree that had spent the winter
indoors blocked her access to it. She set a plank
on the edge of her scooter and made a
ramp up to the windowsill so she could reach
the hose. She leaned out to get it—
and overextended. Thanks to her paralysis,
her lower body could not balance her
and she tipped forward and
out the window.

She was killed by the fall.

24

Two days later, I'm standing with Jack and our friend Steve by the window sill, still thick with the detectives' fingerprint powder.

As I finish telling Steve this story, some RED heart-shaped balloons appear outside the window. Three hearts, one for each of us, hang in the sky, then slowly drift away. Steve says, "How did she do that?"

Goodbye.

The last time I see Patti, she is lying in a box on Second Avenue. They want me to look at her to make sure they burn the right body. At first I can only glance at her face, as if she is something scary, a monster, a nightmare come true. I turn quickly away and say that yes, that had been her. But then I feel it, that it is her, my Pandy, and I have to go over close by her and say goodbye. She sleeps there, her eyes shut, her hair red and soft. I say, I love you, and turn away again. But then I am struck. I will never see her again. Ever. I will leave this place and she will stay and that will be it. I bend over her face and whisper to her. I smooth her hair, I kiss her forehead. I talk to her like I've talked to her a million times before. I feel like I can never leave, because if I do, it will all be really true, and she'll be gone. But the more I hold on, the deeper the pain will grow, and I have to say goodbye now and go. I have to let her do what she has to do, and I have to go my way. I turn away and do not turn back.

Patti Party.

Funeral homes, cemeteries, hearses, coffins, black. They all seem so unPatti. So our friends get a big, wonderful loft and, on Wednesday we throw a raucous, pink celebration.
The crowds spill out in a mob onto the sidewalk. Hundreds and hundreds of people, all wearing something in Patti's favorite color. Pink dresses, pink ties, pink shoes, pink wigs. They bring flowers, cupcakes, guitars, memories, and tears.
People from all aspects of her life — doctors, dog walkers, musicians, fashionistas, teachers — meeting each other for the first time. Sharing stories, jokes, hugs.
Patti brings people together — even after she's gone.

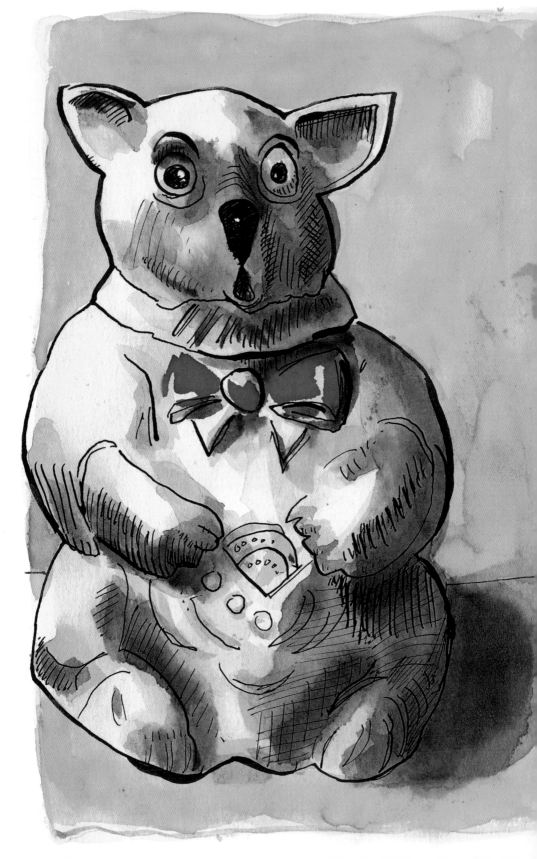

R.I.P.P.L.

I can't imagine putting Patti in a hole in the ground of some outer borough. She needs to stay with us, at home. The undertaker hands me a catalog of urns. She would have hated them all — generic, prefab, sincere, lame.

Patti called me and Jack "Bear". She loved teddy bears. So I empty her favorite cookie jar and carry it to the funeral home.

They pack her ashes inside and I carry it home in a cab. It's surprisingly heavy, like a toddler on my lap. Now she sits in our study, nestled where sweet things belong.

April

I WAS LOOKING AT PATTI'S FACEBOOK PAGE, AT ALL OF THE THINGS SHE SHARED WITH PEOPLE AND A WAVE OF LOSS JUST SWAMPED ME AND KICKED MY ASS. SHE WAS SUDDENLY SO THERE, SO VIVID, HER SILLY ENTHUS- IASMS, HER SMILE, HER EAGERNESS TO BE WITH HER FRIENDS, HER ABILITY TO TAKE A NOTHING DAY AND SUDDENLY MAKE IT ALL SEEM WORTHWHILE. I ENDED UP HUNCHED OVER THE KITCHEN COUNTER, RETCHING OUT TEARS AND MUCUS—UTTERLY BEREFT. I THOUGHT THIS SHIT WAS PAST AND THEN THERE SHE WAS, RIGHT BY ME, SQUEEZING MY LIFELESS HEART. OH, DANDY, WILL I ALWAYS MISS YOU SO MUCH? I HOPE SO. AS I WROTE THIS, ANOTHER FUCKING WAVE HIT ME AND FLATTENED ME, DRIVING ME BACK TO THE KITCHEN, TILL JACK CAME IN TO CONSOLE ME. I REALIZE I'D FORGOTTEN HOW MUCH I MISS HER, I'M NOT USED TO CRYING AND THE PRESSURE CRACKED THE BONES IN MY FACE.

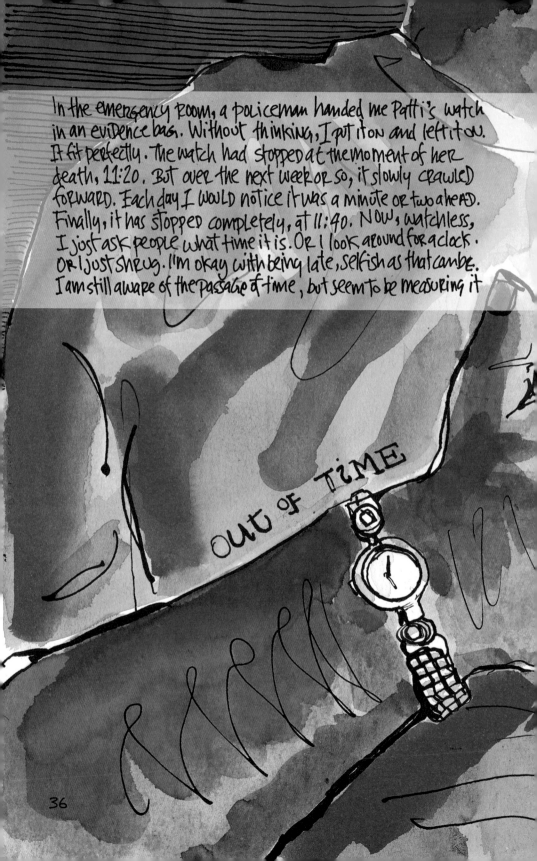

In the emergency room, a policeman handed me Patti's watch in an evidence bag. Without thinking, I put it on and left it on. It fit perfectly. The watch had stopped at the moment of her death, 11:20. But over the next week or so, it slowly crawled forward. Each day I would notice it was a minute or two ahead. Finally, it has stopped completely, at 11:40. Now, watchless, I just ask people what time it is. Or I look around for a clock. Or I just shrug. I'm okay with being late, selfish as that can be. I am still aware of the passage of time, but seem to be measuring it

OUT OF TIME

by a different rhythm. It's less of a tick-tick-tick, time is passing relentless tattoo, and more of an organic drift through the day. I look back each evening and think about what I've done, assess its value, wonder if this is really how I should spend what time I have left. I haven't made any big decisions about that yet, but I do feel more that time is precious, that it must be savored, and that only I should decide how to mete it out.

Not even a wristwatch has that right.

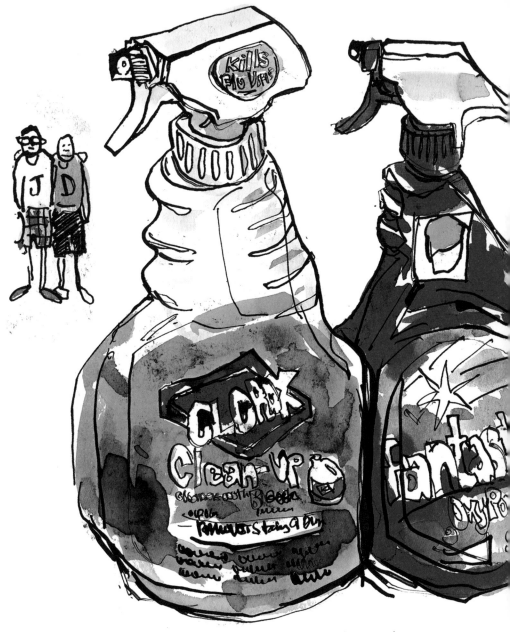

Here's where I begin. Cleaning up my apartment, on my hands— dismissing the cleaning ladies who had scrubbed my toilets ever since I could afford them— Reclaiming what is mine, filth and all.

CAN DOUBLE AS A BROOM.

HEY! WE MADE IT FILTHY TOO!

DID NOT!

Being married means sharing the good, the bad, the important, the mundane. Patti and I leaned on each other in a thousand ways: she would shop, I would cook. I would bring home checks, she would pay bills. She kept up with our friends, I worked late. It was a deep symbiosis developed over 23 and 7/8 years– which unraveled in a heartbeat.

Cleaning up our act.

SCRUB SCRUB SCRUB SCRUB SCRUB SCRUB SCRUB

So now I am forced to reappraise all the decisions we made as a team.

Is that the right shelf to store the wine glasses on? Do we need all of these dish towels? Should we live in New York? One by one, I pick them off; making lists, adding bleach, filling my weekends with chores.

Every choice is made in consultation with Patti's ghost, with serious consideration of what she intended, what she thought I wanted, of how to stay true to her spirit, yet accommodate our changed reality. Sometimes it's terribly sad. Often, it's a form of companionship that keeps her in my heart, in my pantry, in my thoughts as I doze off.

It's daunting, it's a doable... it's under way.

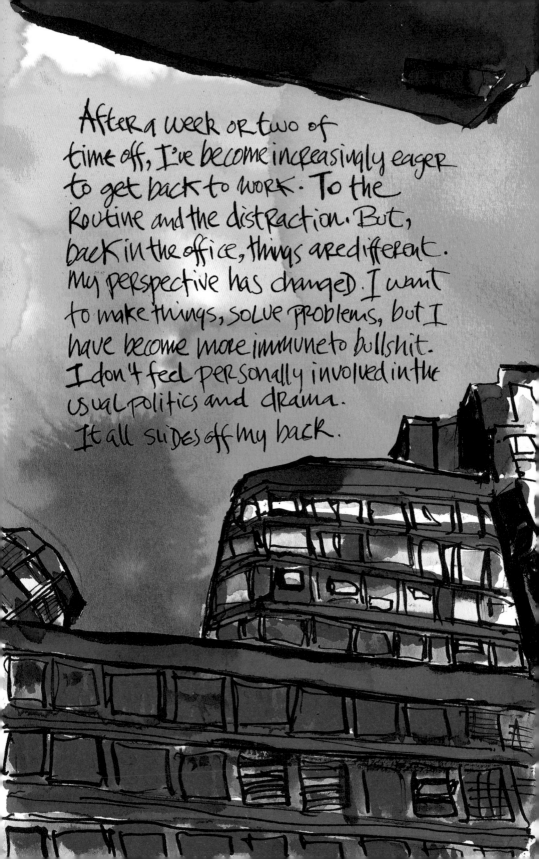

After a week or two of time off, I've become increasingly eager to get back to work. To the routine and the distraction. But, back in the office, things are different. My perspective has changed. I want to make things, solve problems, but I have become more immune to bullshit. I don't feel personally involved in the usual politics and drama.

It all slides off my back.

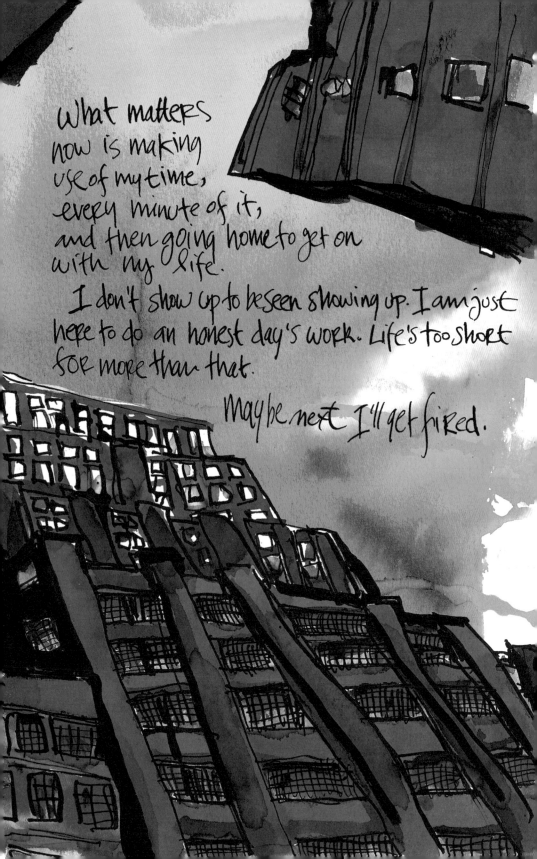

What matters now is making use of my time, every minute of it, and then going home to get on with my life.

I don't show up to be seen showing up. I am just here to do an honest day's work. Life's too short for more than that.

Maybe next I'll get fired.

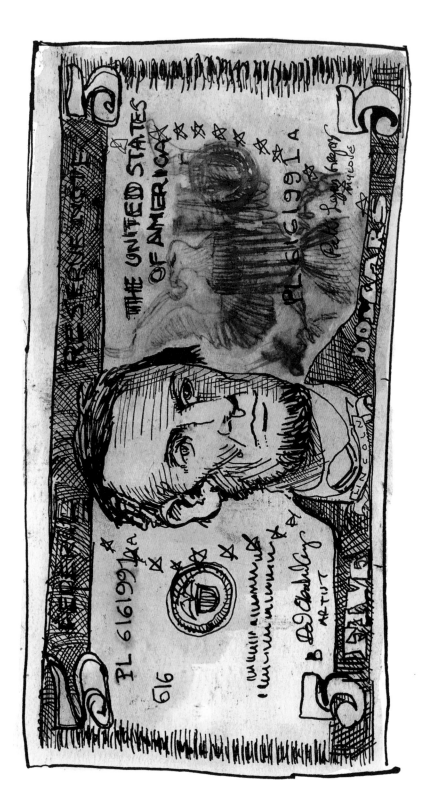

Pennies from HEAVEN?

Earlier this year, a friend told me that she and her husband started setting aside any five dollars bills they found in their wallets each night. The money they saved went into a special fund to do something fun with by year's end. Patti and I decided to do the same. We only did for a few weeks but managed to set aside a hundred bucks or so. Two days after Patti died, I found a mint five dollar bill under my chair. It was folded perfectly in quarters. Three days later, I found another brand new $5 bill, folded in four, on the ground by the produce section in the supermarket.

In the months since, I've never found another five dollar bill on the floor. Just as well, as the first two freaked me out.

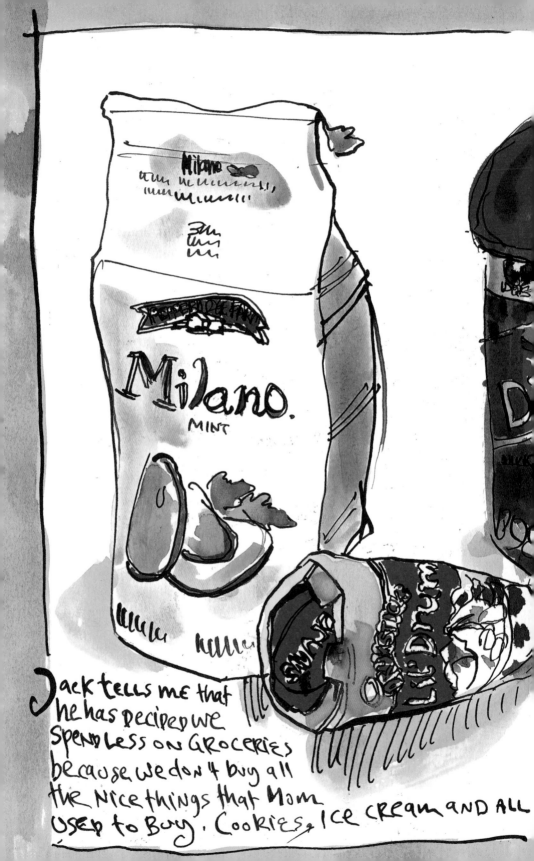

Jack tells me that he has decided we spend less on groceries because we don't buy all the nice things that Mom used to buy. Cookies, ice cream and all

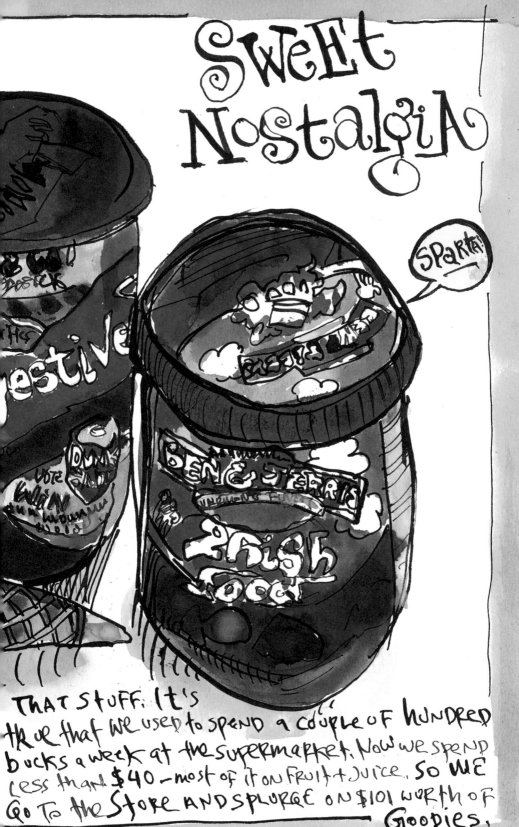

THAT STUFF. It's
true that we used to spend a couple of hundred
bucks a week at the supermarket. Now we spend
less than $40 - most of it on fruit + juice. SO WE
GO TO the STORE AND SPLURGE ON $10! WORTH OF
GOODIES.

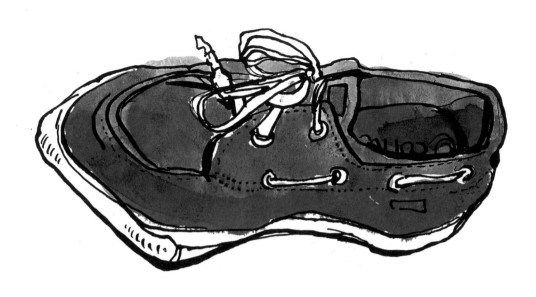

Jack and I have always shared certain things: pens, a love of R. Crumb, a disdain for Dane Cook. Now we have a new and more complex relationship, one that can be annoying and claustrophobic sometimes, rich and vital at others. We are roommates, creative collaborators, dinner companions, advisors, and dad and son. And there's no Mom to act as a buffer, filter and coder-head.

It can be tough living with a teenager who doesn't realize he is shedding clothes all over the house or drinking the last of the juice. I'm sure it's just as tough for Jack living with a cantankerous, sappy weirdo. Despite our differences, we are managing okay, crafting a new sort of life in our man cave, surrounded by chip packages and wiener dogs.

Most recently, we've taken to sharing a pair of blue shoes that we both coveted. It's been a true compromise as the shoes are a little small for Jack, a little large for me. The experience has proven useful, teaching us what it's like to walk in each other's shoes.

47

Our hounds were Patti's babies. They traveled all over town with her, Tim riding in the basket of her scooter, Joe on the platform by her feet. She would hug them close, dress them in raincoats and a little duck suit, bring them to bed, and spoil them with treats. They licked her, hugged her back and guarded her, barking whenever a stranger got too close,.

People asked me if they noticed her absence.

I didn't know how to tell. It's not like they were hanging around the door waiting for her to come home or howling with grief. They seemed more or less the same. Except for the total breakdown in housebreaking. Horrible, squirty diarrhea. Puddles of pee all over.

I spent a few hundred dollars at the vet and put them on antibiotics. It went away, sort of, but not entirely. At the hippy pet store, they prescribed pumpkin and squash, cans of duck and venison. I tried it all and after four weeks or so, things calmed down. When I ran out of cans of expensive handmade food, I switched them back to dry food and they have been fine ever since. Except for when we went away overnight to my mum's house and they stayed with strangers. Again, diarrhea.

Then it hit me. Duh, they were stressed out and this is how it manifests. No support groups or condolence cards. They just want normalcy.

Grief is a messy business. This kind can be taken care of with a mop, water and Mr. Clean.

And a coupla biscuits.

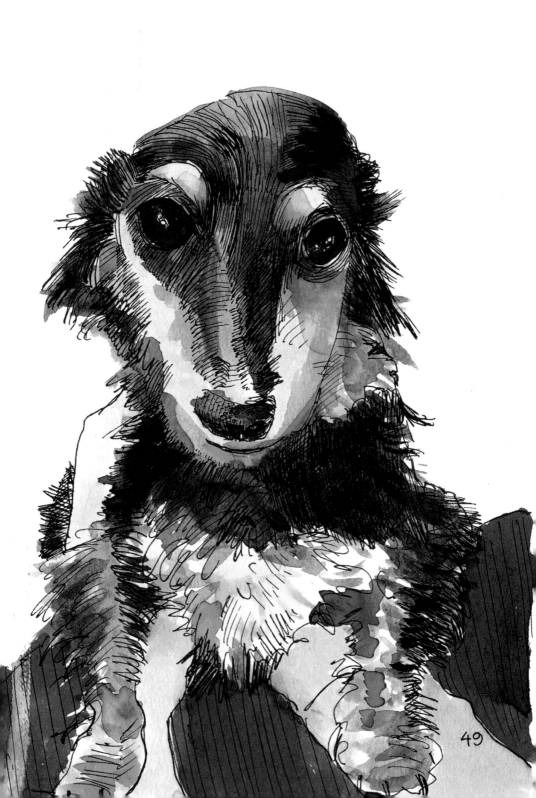

49

People say

"How are you?" and I say,
"We're getting on. Life is Reforming, Recomposing, and we are okay."
I say it because it's true and because I don't know what else to say. Any other words would mean an outpouring of some sorts, and who can live with that every time I see anyone I know? I am scabbing over and I can't keep pulling back the band-aid to discuss what's underneath.

WEB

HOOF

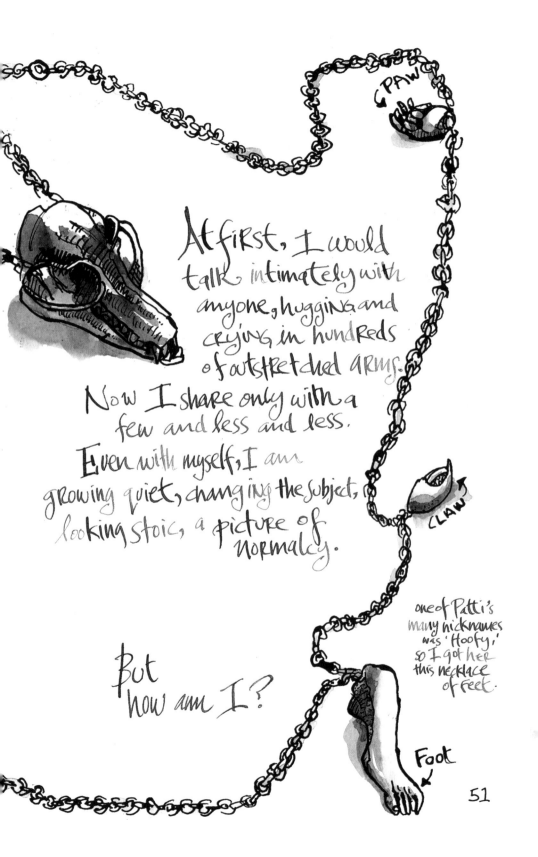

At first, I would talk intimately with anyone, hugging and crying in hundreds of outstretched arms.

Now I share only with a few and less and less. Even with myself, I am growing quiet, changing the subject, looking stoic, a picture of normalcy.

But how am I?

PAW

CLAW

one of Patti's many nicknames was 'Hoofy,' so I got her this necklace of feet.

Foot

51

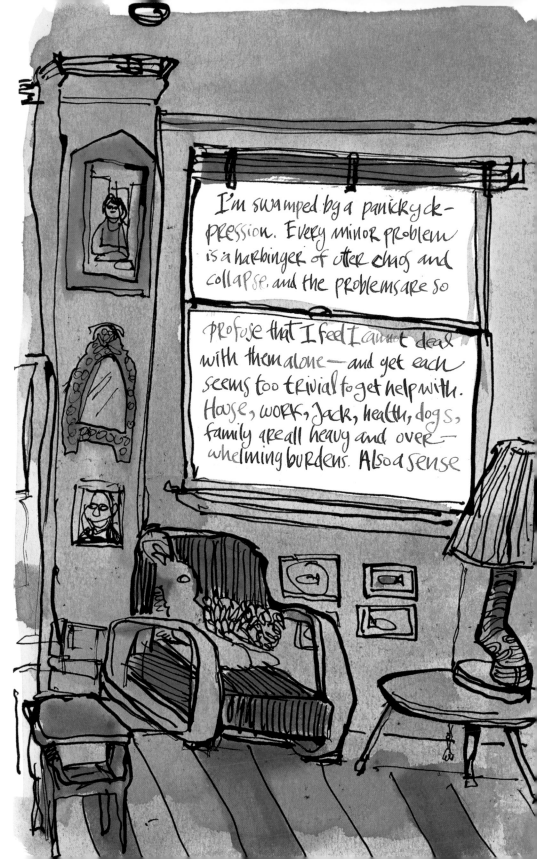

I'm swamped by a panicky de-pression. Every minor problem is a harbinger of utter chaos and collapse, and the problems are so

profuse that I feel I cannot deal with them alone—and yet each seems too trivial to get help with. House, work, Jack, health, dogs, family are all heavy and over-whelming burdens. Also a sense

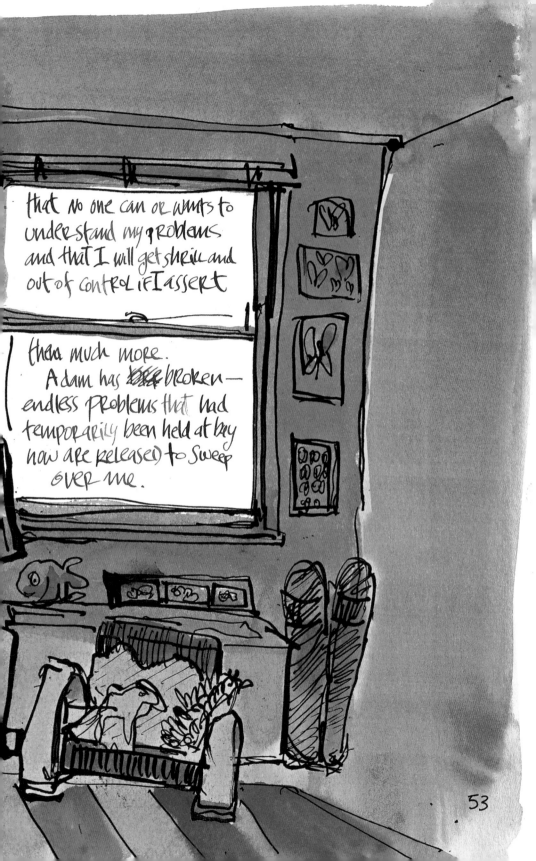

that no one can or wants to understand my problems and that I will get shrill and out of control if I assert

them much more.
Adam has ~~been~~ broken — endless problems that had temporarily been held at bay now are released) to sweep over me.

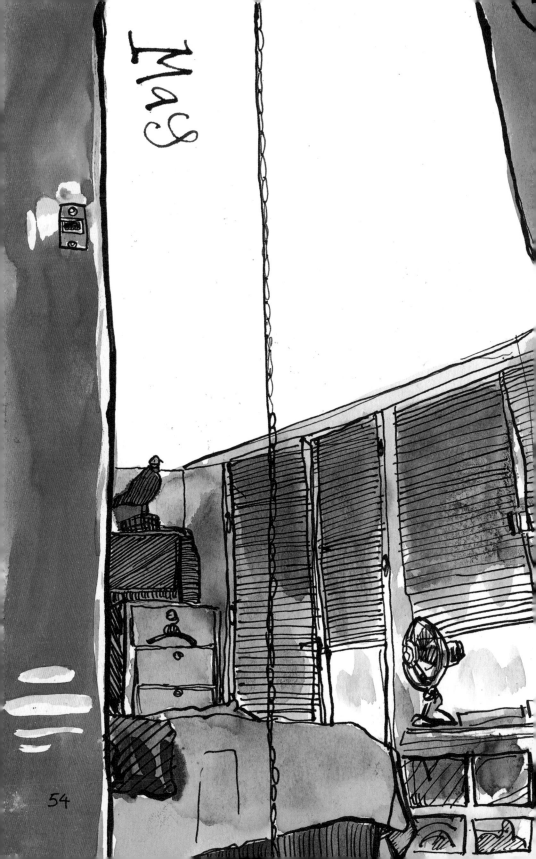

May

54

HOLE.

I call Matthew, Patti's handyman, AND ask him to come over to discuss fixing the HOLE IN OUR BEDROOM door — it was bashed in by the POLICE ON MARCH 18th as they TRIED to get in to investigate. HE SHOWS UP a WEEK LATE AND says he can't talk about P as it will make him FEEL too BAD. I am matter of fact — paint the scrapes her chair

MADE IN the HALLWAY, FIX the HOLE, etc. But will IT REALLY FIX anything?

The big things that have changed are not the ones I feared. I thought it would be all about having someone to hug and kiss, a hand to hold, eyes to stare into, maybe just someone who would always get my jokes, indulge my point of view.

But it's all the things that Patti did in her life that were melded into mine that have left me like a one-armed man. Running our house, the practical aspects of our lives, what sort of garbage bags to buy, who to invite for dinner, where to spend the summer, when to pay the mortgage.

Every day is filled with a thousand things we would discuss, How does this shirt look? What should we have for dinner? What do we buy my sister for her birthday? Should we repaint the hall? How do I deal with my boss? Do you like this sentence? Am I a good person?

I'd pick up the phone, send a text or an email, every hour or two, just to stay in touch, to course correct. Now, over and over again, I find myself starting to dial, then I drop the phone, realizing my mistake, that Patti's unable to come to the phone right now, Patti's not home.

I've been trying to share my life...

...but now it belongs to me alone.

I dreamt I was at a wedding, a couple I apparently worked with. The groom was Swedish and his sister, also a colleague, was happily talking about all of the traditions, the many ways the couple celebrated their love.

wet dre

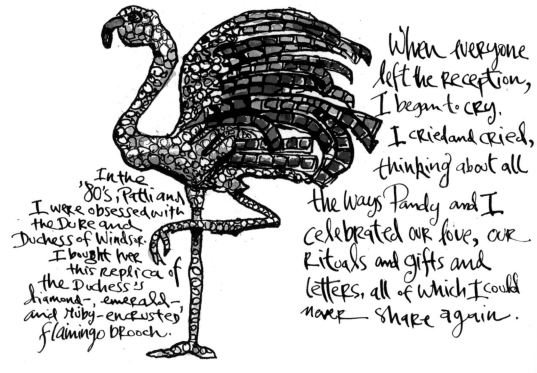

In the '80's, Patti and I were obsessed with the Duke and Duchess of Windsor. I bought her this replica of the Duchess's diamond-, emerald-, and ruby-encrusted flamingo brooch.

When everyone left the reception, I began to cry. I cried and cried, thinking about all the ways Pandy and I celebrated our love, our rituals and gifts and letters, all of which I could never share again.

I woke up feeling as if I had been weeping hard, as if the feelings were hidden in me and had to come out while I slept.
I have not cried in over a week, not even on Sunday, which was Mother's Day.

am. I am getting on with life, I think, which seems to mean packing away the rituals and memories in straw and gossamer because I can no longer share them...

...and I "need my heart back."

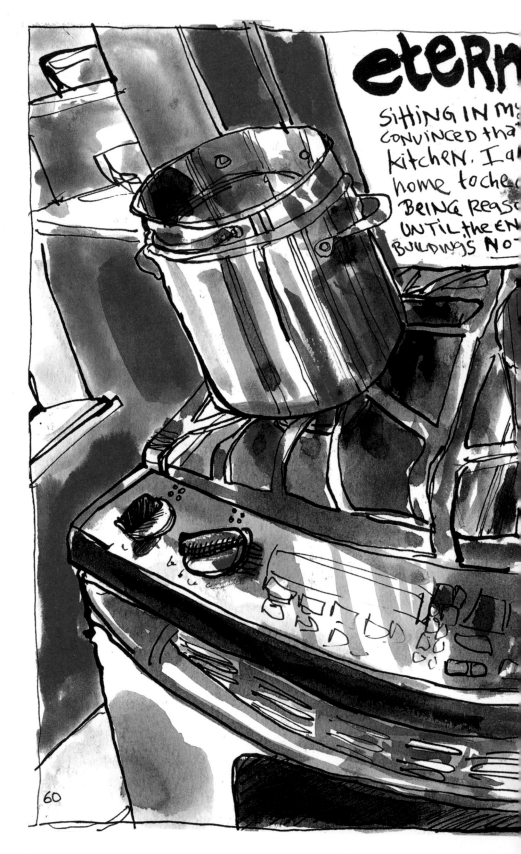

eterN

SITTING IN M...
CONVINCED that...
kitchen. I a...
home to che...
BEING Reas...
UNTIL the en...
BUILDINGS NO...

aL FiAme.

...FFICE, I GROW INCREASINGLY ...left the gas ON IN the ...ost get UP aND RUN ...OUT & ALK MYSELF INTO ...BLE. I don't FULLY RELAX ...OF the DAY WHEN I see my SURROUNDED BY FIRE TRUCKS.

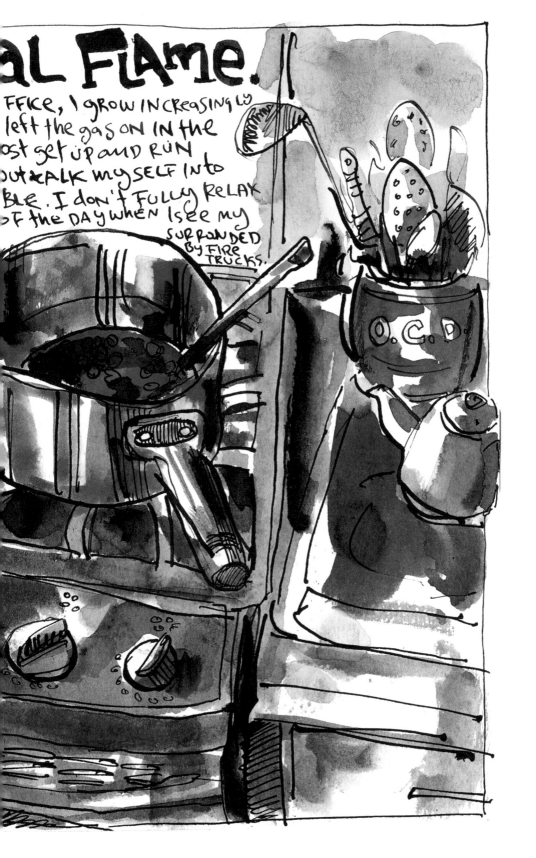

I am packing Jack's lunchbox, when my pal Dan calls me to say: "The Universe picked you and decided to test you. It decided you were strong and had every-thing and so it would throw you a curve. First, Patti had her accident and it watched to see if you would crawl into a hole or would make the most

of the experience. When it saw that you had become stronger and wiser, had discovered that every day matters, the universe decided to test you again by taking Patti away altogether. Now it's waiting to see what you will make of this, will you use it to learn, to share what you learn, to make the world a better place? The universe is just waiting to see."

I say, "Why can't the universe just leave me the fuck alone?"

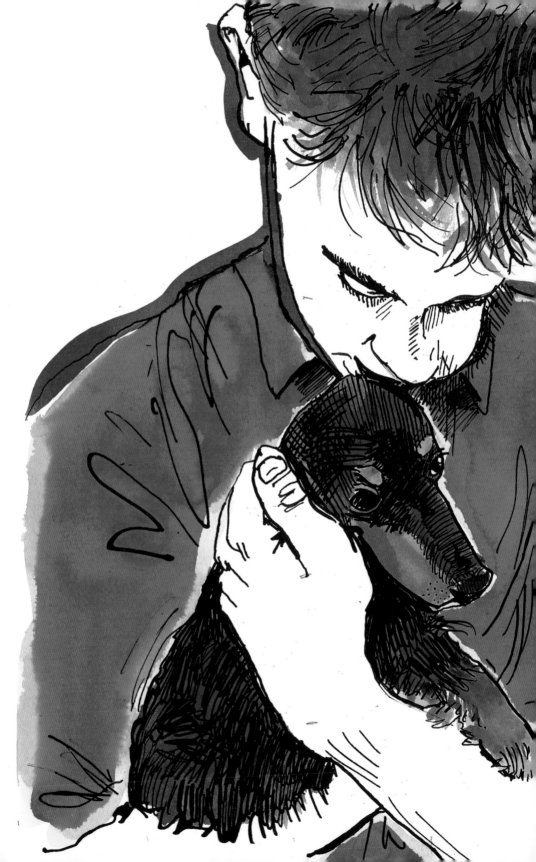

Others can commiserate but my loss is mine and unique. I cannot properly express my feelings. They're too complex.

My other friends listen and help but they are not as frank as in other sorts of conversations. They sit in mute support, but I think, "you have not been here and can't really know what it's like..."

I don't know if I do either. Sometimes it's as if my brain just got hurt and needs to be held like a wounded animal. That only time can heal it. That it's too much to ask anyone else to fix it.

And sometimes I feel I am doing it wrong, not adequately tending to myself, reducing a twisted ugly scar that will mark me forever. I can stop, yet I must go on. Neither is right. No one can help me, and yet I must not retreat into myself or bury my pain too deep. I don't know how to guide myself, yet no one else can adequately explain or even console me. I get angry because I want to stop, and yet I must keep going because time seems so short. I may not have much left but it is my only savior.

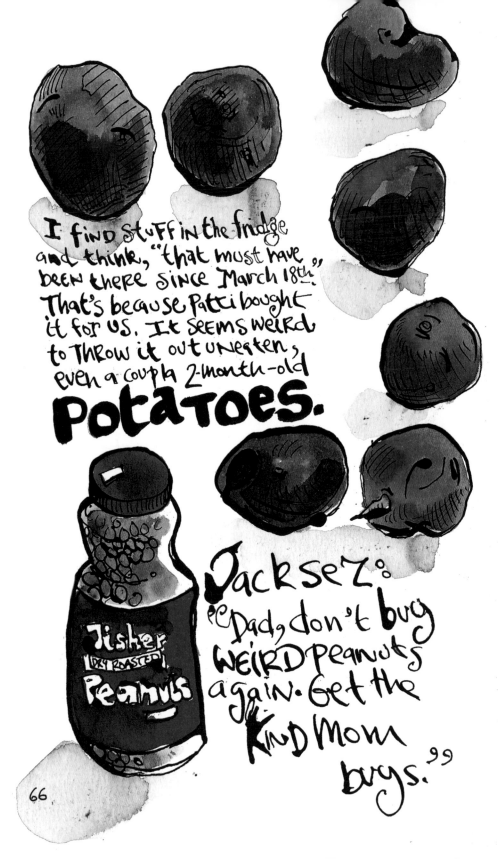

I find stuff in the fridge and think, "That must have been there since March 18th." That's because Patti bought it for us. It seems weird to throw it out uneaten, even a coupla 2-month-old POTATOES.

Jack sez: "Dad, don't buy WEIRD peanuts again. Get the kind Mom buys."

Fisher DRY ROASTED Peanuts

We no longer watch many of our favorite shows—Law and Order, CSI, Medium—anything to do with police and death. Also shows that make us miss Patti too much to be entertaining.

Last week, Jack said, "When I think about Mom, sometimes it's like a character on a show we don't watch anymore."

Being married and middle-aged meant the gradual spread of my waistband, a souvenir of all those evenings when Patti would bring me a bowl of ice cream on the couch.

I lost my appetite altogether during those first horrible weeks in March. But even when it returned, food wasn't especially comforting. Now our pantry is bare-ish. Jack and I buy just enough cold cuts and fruit for his lunches, cereals for my breakfast. These days, Jack complains, my favorite word is "Sparta."

I have lost the equivalent weight of both my hounds combined.

Waisting Away.

For the first time in ages, I go to the gym and like it. And I have the time. When Patti was alive, time spent on myself was time taken away from her. Now I let myself indulge in new ways. Fortunately, so far, most of them are healthy.

I have a new perspective on my age, on how many years I have left: I had always assumed that Patti and I would march into the grave holding hands and I had no special interest in outliving her. Now as I plan the rest of this journey with no one to lean on, I need to wise up. Both my parents are healthy and robust in their seventies and my grandfather lived to 98. Chances are I will be around to choose apples, tap melons, lift dumbells and fill sketchbooks for a little bit longer. In the meantime, I need new trousers and a shorter belt.

June

Fruit Man.

Patti loved the little guy who sells
Fruit on our corner — I continue her
tradition, buying more raspberries
and bananas from him than we can
ever get through. They turn colors,
black and blue, in piles in bowls
in our kitchen.
The fruitman was one of the first people
to come up and hug me, his beady eyes
streaming, way back in March. His
English is so rudimentary, his emotions
so raw, that I just hugged and hugged
him back. And so he continues to
feed us and our occasional flies,
a bond, like so many Patti forged,
that I try to keep whole. At least
we won't die of scurvy.

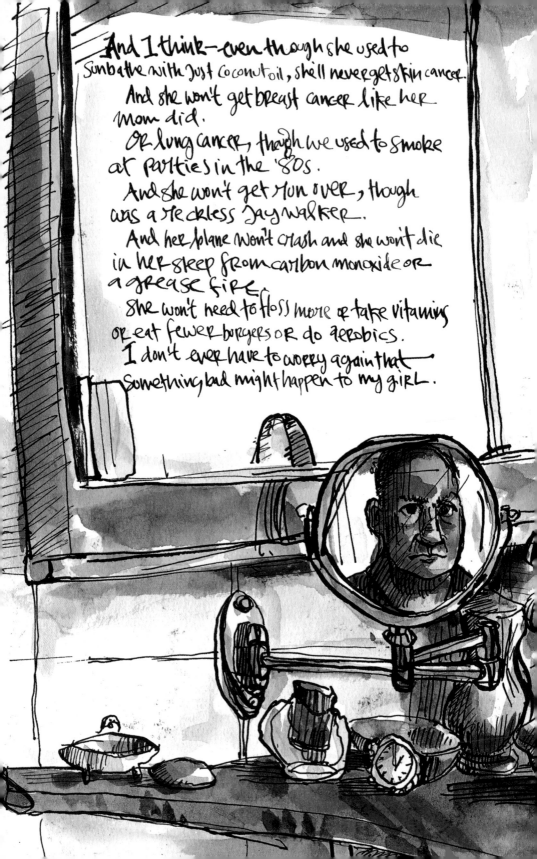

And I think—even though she used to
sunbathe with just coconut oil, she'll never get skin cancer.

And she won't get breast cancer like her
mom did.

Or lung cancer, though we used to smoke
at parties in the '80s.

And she won't get run over, though
was a reckless jaywalker.

And her plane won't crash and she won't die
in her sleep from carbon monoxide or
a grease fire.

She won't need to floss more or take vitamins
or eat fewer burgers or do aerobics.

I don't ever have to worry again that
something bad might happen to my girl.

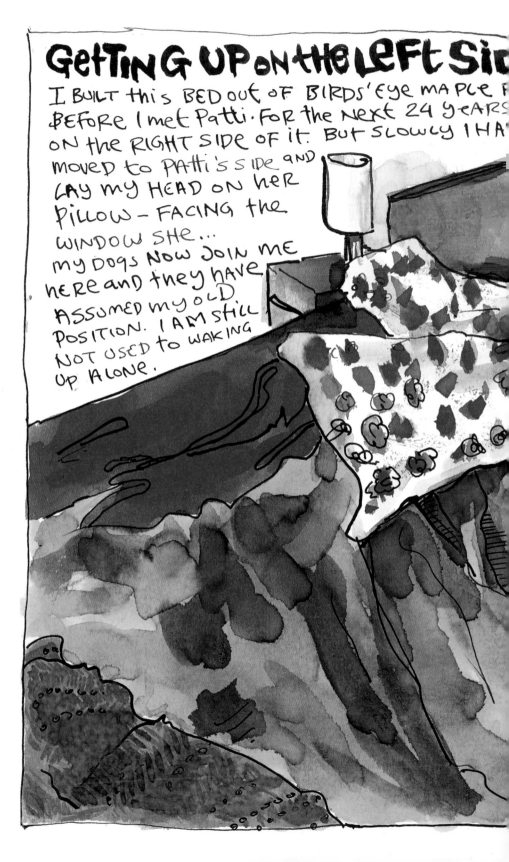

GETTING UP ON THE LEFT SIDE

I BUILT THIS BED OUT OF BIRDS' EYE MAPLE
BEFORE I MET PATTI. FOR THE NEXT 24 YEARS
ON THE RIGHT SIDE OF IT. BUT SLOWLY I HAVE
MOVED TO PATTI'S SIDE AND
LAY MY HEAD ON HER
PILLOW — FACING THE
WINDOW SHE...
MY DOGS NOW JOIN ME
HERE AND THEY HAVE
ASSUMED MY OLD
POSITION. I AM STILL
NOT USED TO WAKING
UP ALONE.

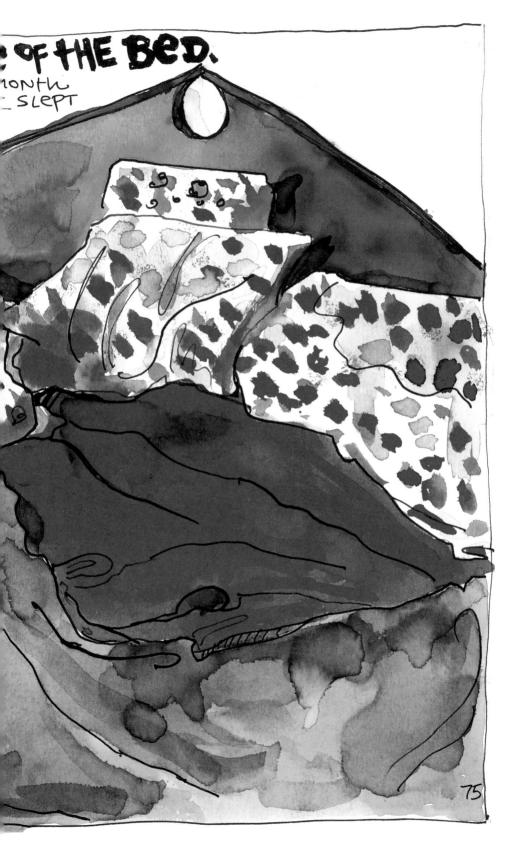

OF THE BED.

MONTH
SLEPT

75

Six One Six

616 was always an important number to us. Our meeting date, our wedding. We usually called each other every day at 6:16 PM. We marked all the times that our restaurant bill would add up to some variation of the number. It still comes up; I ordered something from Amazon last weekend. Shipping and Handling: $6.16. It was a funny thing to look for, but we knew it was just a long chain of coincidences. Superstition was just a fun pattern, a way to connect, like playing I Spy.

Wednesday was 6.16 again. As I have every year, I went to 18 W. 18 Street where we met and wed. This year, I went with my sister, Patti's maid of honor. Over the years, what was once a restaurant, then another, and another, is now a children's bookshop. Where we stood to be joined till death did us part, there's now a cupcake counter. The cupcakes are made by the Cupcake Café. When Patti had her subway accident, she was on her way to pick up a cake from the Cupcake Café. She never made it, ending up instead in St. Vincent's Hospital (where she was declared dead, 14 years later, a week before the hospital was closed down forever). Two weeks later, on 6.16.1996 she missed going to 18 W. 18 St on 6.16 for the very first time. This year she missed it again. Coincidence upon coincidence, but, sadly, proof of nothing.

76

July

I am changed most because my future is blank. The many plans and decisions we made over the past 24 years are gone. Instead, I have to form a new map, a new set of goals, a new vision of what I'll be in the years ahead.

Patti and I were meant to keep growing old together, to leave the city one day, go somewhere warm and easy, watercolor side-by-side, visit Jack and our grandchildren, feel free in new ways, live a full creative life. Now, it's just empty. Not bleak or barren, but blank. I could do anything.

The security I have been saving for all these years seems irrelevant now. I have to provide for Jack till he graduates... but then what? Who will I be? What will I want? I have no idea.

The road bends. New obstacles and opportunities, ditches and valleys appear. I take them turn by turn, mile by mile, step by step. Head up when I can keep it up. Looking back now and then, but still moving forward.

In the PARK

I was walking
the dogs in
the park when a couple
recognized Tim and
Joe and came up to ask
how Patti was doing,
saying they hadn't
seen her in months.
I explained why.
They were stunned, saying
they saw her every morning in
the park, couldn't believe that
someone so full of life
could be gone.
I was reserved,
stoic, absorbing
their shock.

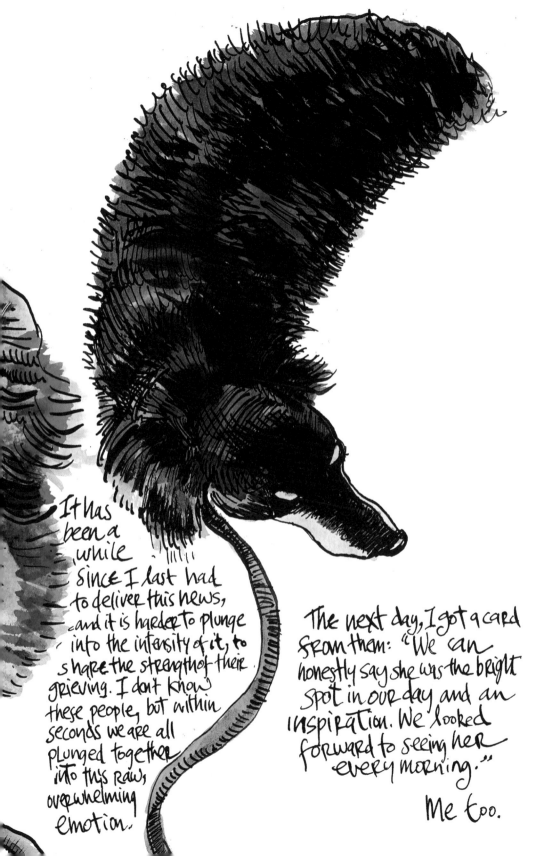

It has been a while since I last had to deliver this news, and it is harder to plunge into the intensity of it, to share the strength of their grieving. I don't know these people, but within seconds we are all plunged together into this raw, overwhelming emotion.

The next day, I got a card from them: "We can honestly say she was the bright spot in our day and an inspiration. We looked forward to seeing her every morning."

Me too.

I am reading The Lovely Bones. It makes me sad and I don't know why I keep turning the pages. Susie Salmon watches her family from the afterlife. She feels their pain, wishes she could contact them, but is just a little girl forever more,

Ghosts

beyond their reach. She believes that she's in Heaven, but to me it seems like Hell.

I wish I could believe in ghosts or angels or spirits. People write to tell me that Patti is in Heaven, or watching over us, or waiting for us, or sitting with God ... it would be so nice to think that she is hanging out with her mother and my grandmother in some wonderful place, and that we will join her soon and be with her forever.

I have tried to believe it. Tried and failed. There is not even a flicker of doubt in my mind that Patti exists only in the cookie jar in my study.

Despite that, Patti does live on.

Just like my grandmother will always exist in the way I make beds, spread cream cheese on toast, or tend my garden;

So I don't need Patti to hover around my head or wear wings or leave me five-dollar bills neatly folded in fours. I don't need to light candles for her or say Kaddish. I just need to hold her in my mind, if not my arms to enjoy each new day like she did. It's a simple goal, a little trite, but easy to believe in even for an old skeptic like me.

August

Jack has always balked at having a birth-day party — the last one was when he turned eight. This year, a couple of his buddies invited him to hang out on the Great Lawn in Central Park. When they arrived, 30 or so of his friends from middle and high school were there to surprise him with cake and presents. It was so sweet that they all came together just for him, and he was really happy and touched. It made me very proud that so many people love my boy.

What's Past is Prologue.

It's funny how decisions Patti made, sometimes long ago, impact my daily life.

Like the back-ordered blouse that was just delivered by UPS and sits on her desk unopened.

Or the brand-new wheelchair she ordered to replace her 12-year-old clunker. It was on the truck to be delivered on the day she died and, amidst the funeral arrangements, I remembered it and we managed to cancel the shipment.

I like the interruption of these messages from her, her mind working in the past and appearing in the present, like the bulbs she planted last fall that popped up in late march after she was gone.

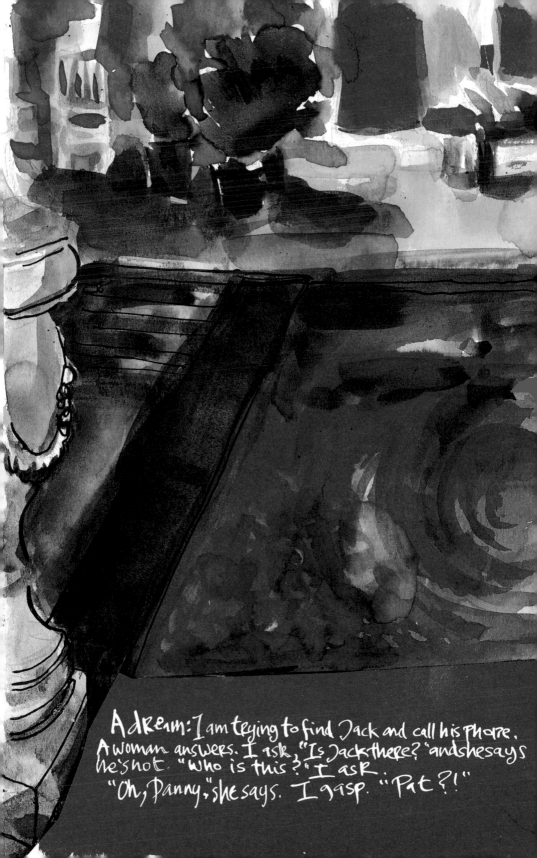

A dream: I am trying to find Jack and call his phone.
A woman answers. I ask, "Is Jack there?" and she says
he's not. "Who is this?" I ask.
"Oh, Danny," she says. I gasp. "Pat?!"

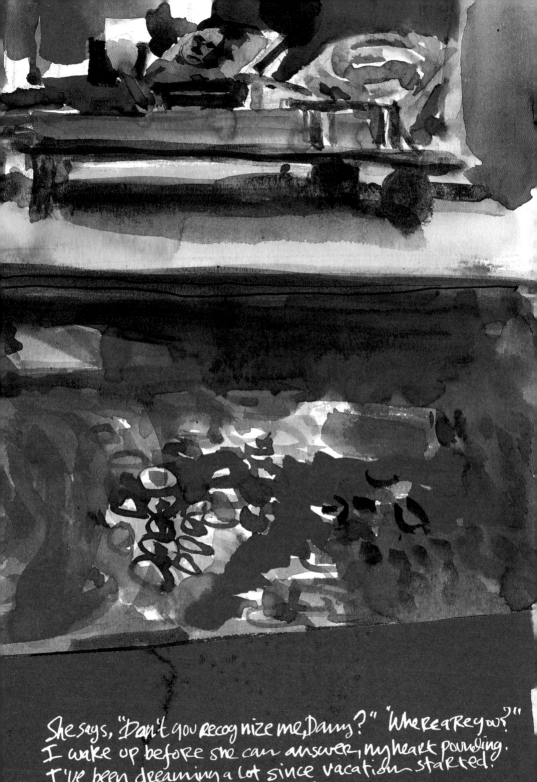

She says, "Don't you recognize me, Danny?" "Where are you?"
I wake up before she can answer, my heart pounding.
I've been dreaming a lot since vacation started.
This is the weirdest one yet.

87

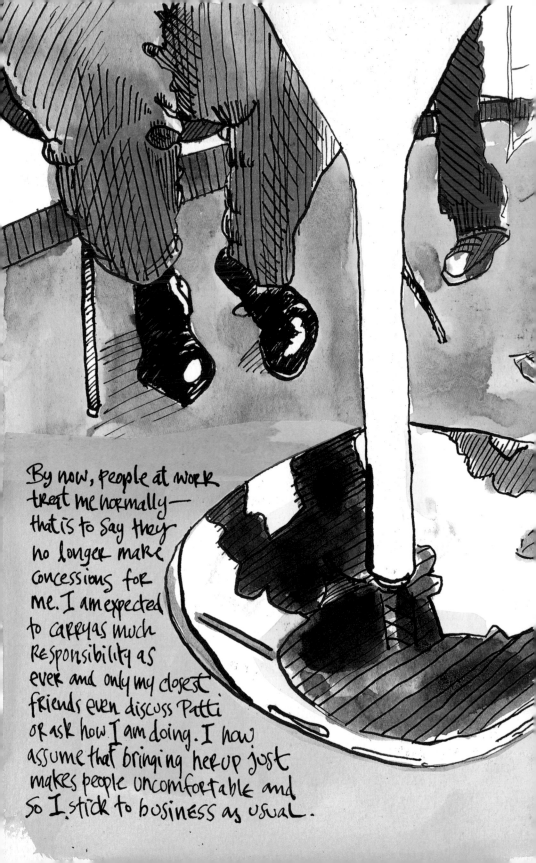

By now, people at work treat me normally— that is to say they no longer make concessions for me. I am expected to carry as much responsibility as ever and only my closest friends even discuss Patti or ask how I am doing. I now assume that bringing her up just makes people uncomfortable and so I stick to business as usual.

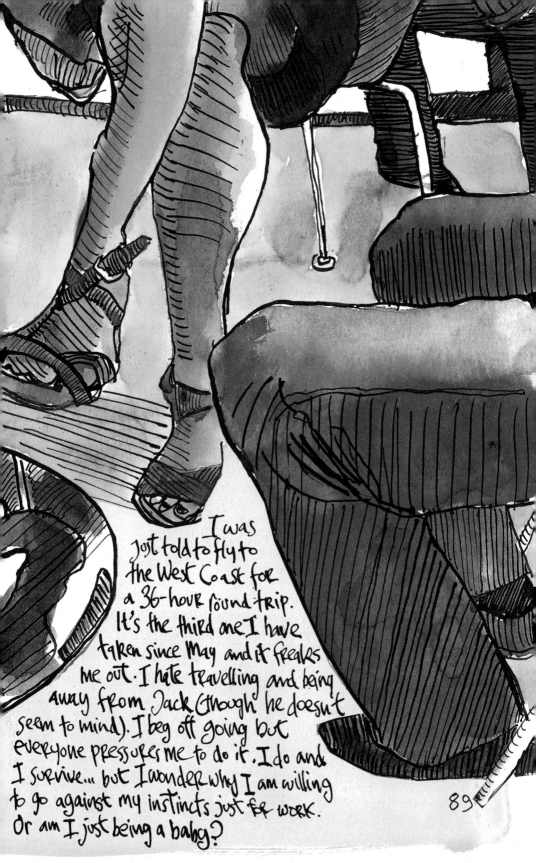

I was just told to fly to the West Coast for a 36-hour round trip. It's the third one I have taken since May and it freaks me out. I hate travelling and being away from Jack (though he doesn't seem to mind). I beg off going but everyone pressures me to do it. I do and I survive... but I wonder why I am willing to go against my instincts just for work. Or am I just being a baby?

89

90

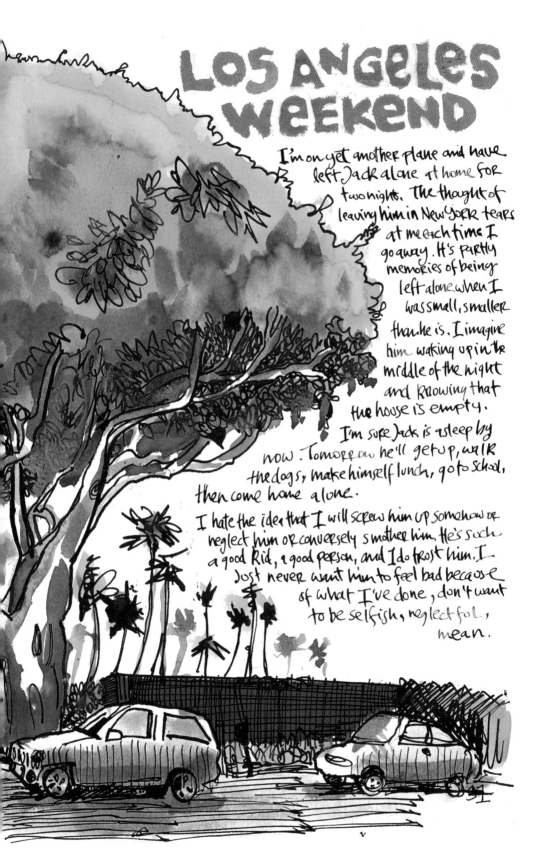

LOS ANGELES WEEKEND

I'm on yet another plane and have left Jack alone at home for two nights. The thought of leaving him in New York tears at me each time I go away. It's partly memories of being left alone when I was small, smaller than he is. I imagine him waking up in the middle of the night and knowing that the house is empty.

I'm sure Jack is asleep by now. Tomorrow he'll get up, walk the dogs, make himself lunch, go to school, then come home alone.

I hate the idea that I will screw him up somehow or neglect him or conversely smother him. He's such a good kid, a good person, and I do trust him. I just never want him to feel bad because of what I've done, don't want to be selfish, neglectful, mean.

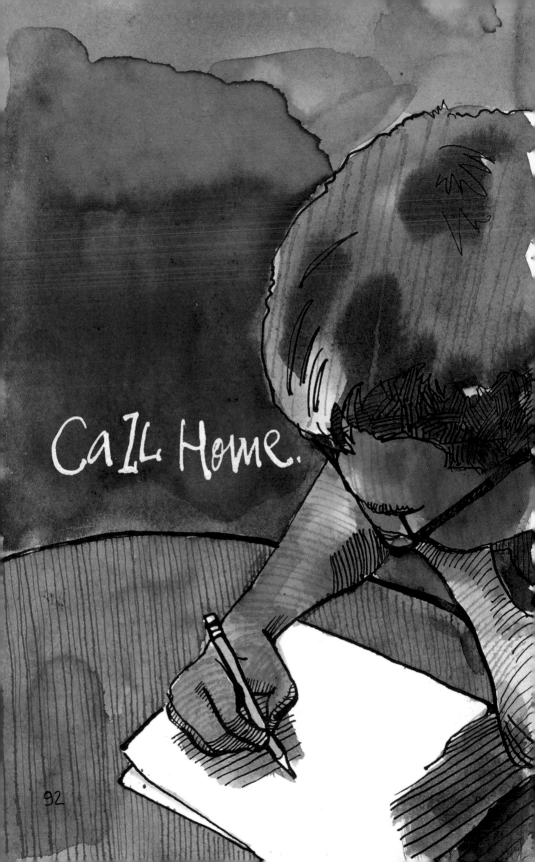

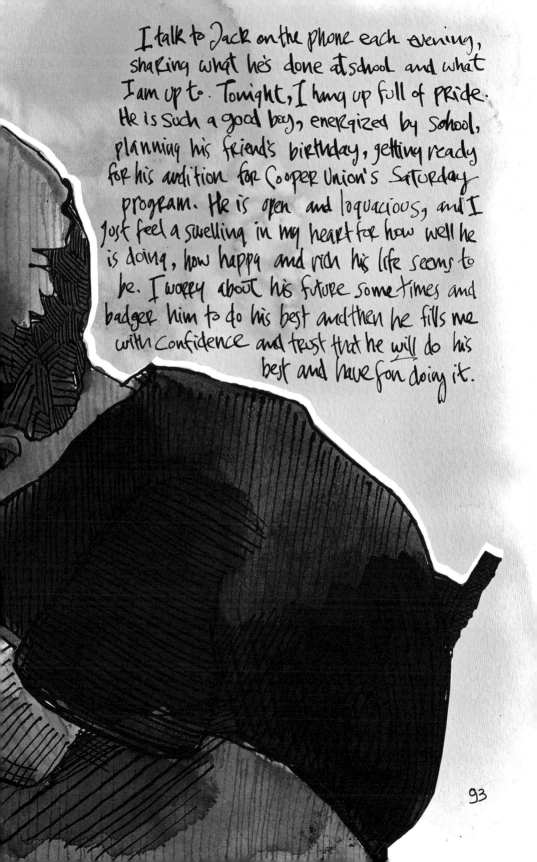

I talk to Jack on the phone each evening,
sharing what he's done at school and what
I am up to. Tonight, I hung up full of pride.
He is such a good boy, energized by school,
planning his friend's birthday, getting ready
for his audition for Cooper Union's Saturday
program. He is open and loquacious, and I
just feel a swelling in my heart for how well he
is doing, how happy and rich his life seems to
be. I worry about his future sometimes and
badger him to do his best and then he fills me
with confidence and trust that he will do his
best and have fun doing it.

93

September

94

men.

My buddy comes to stay with me from out of town and we go drawing in the streets. He's spent most of his life living alone without a woman and I see how differently it makes him see the world— how weird a purely male perspective can be, undiluted by a woman's, by another person's. Cut your own hair, dress for comfort and durability. Eat weird stuff, how and when you want. Develop attitudes that work fine in your head but are oddball when they come out in the bright light of day. It's easy to devolve back into a caveman.

I better watch it.

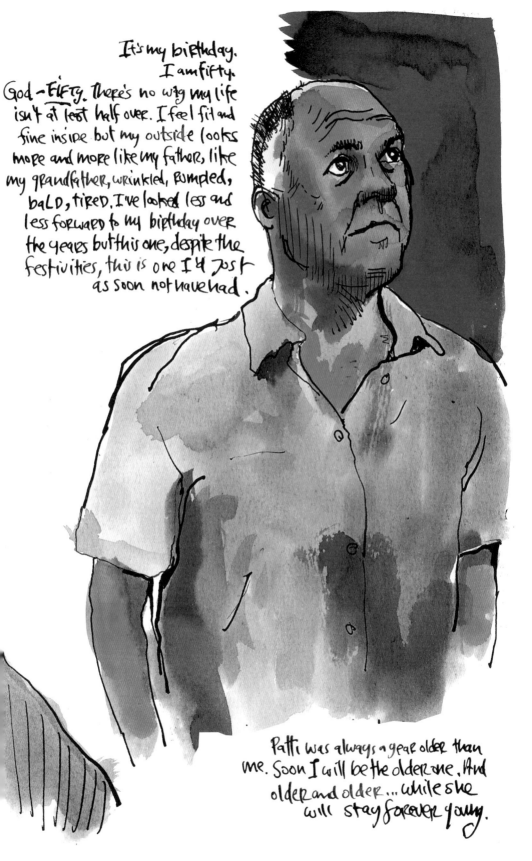

It's my birthday. I am fifty. God – FIFTY. There's no way my life isn't at least half over. I feel fit and fine inside but my outside looks more and more like my father, like my grandfather, wrinkled, rumpled, bald, tired. I've looked less and less forward to my birthday over the years but this one, despite the festivities, this is one I'd just as soon not have had.

Patti was always a year older than me. Soon I will be the older one. And older and older... while she will stay forever young.

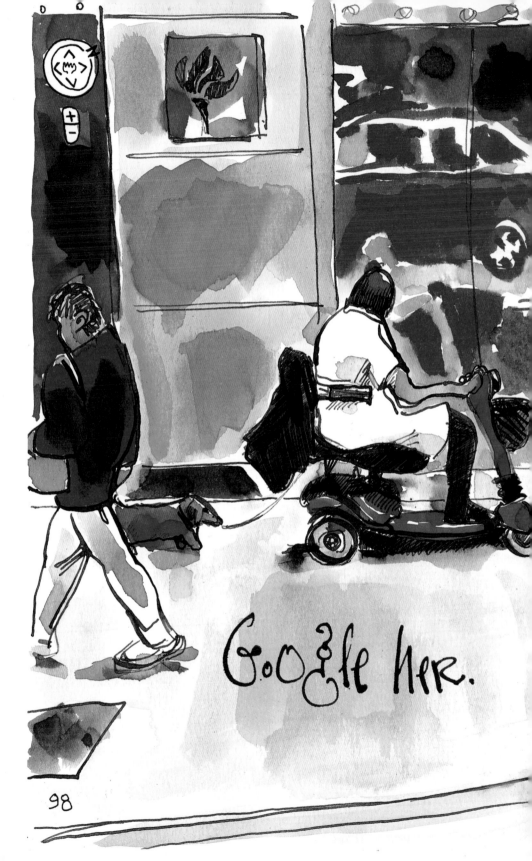

When you look up our street on Google maps, there's Patti walking Joe. She's still alive in there, still doing her thing, just like always.

She keeps reappearing in my dreams too, saying she's come back, saying she hopes we're okay, telling me she has been watching us all this time.

They are unsettling,

but I like these virtual visits.

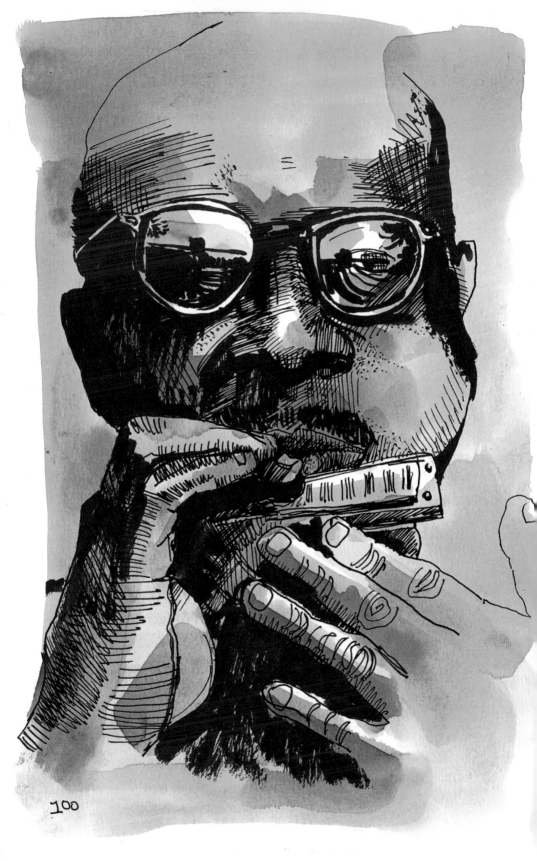

100

SAD SONGS.

Patti loved music, rolling around the house in headphones, singing along with her iPod. She had friends who were street musicians and rock stars. She sent elaborate care packages to Aimee Mann, Cheap Trick, David Bowie, Moby. If she loved a song, she'd wear it out. Her itunes menu showed she had played Coldplay's "Viva La Vida" 72 times the month it came out.

Our romance was full of love songs. We shared so much music, memorizing lyrics, singing loudly together, even though we couldn't sing. Opera, bubble gum pop, jazz standards. It didn't matter. Sometimes I'd play the harmonica in the shower while she made up blues songs outside.

Now I can hardly listen to any music at all. Every song seems to have some connection to our past together and breaks my heart.
But Jack lies in his room and listens to her favorite songs, communing with his mom.

101

102

WHO CAN TURN THE WORLD ON WITH HER SMILE?

Todd reminds me of the summer when Patti was on bed rest and then had to go to Mount Sinai, how she was first sentenced to six months on a waterbed in their spinal cord injury ward. He visited her with a big bucket of KFC, which they placed between her legs where the hot water of the bed kept it warm and filled the ward with an intoxicating smell. Together they made garlands which he draped across the ceiling so she would have something nice to look at. She shared the flowers and the chicken with the ward. The nurses, beguiled, let her break rules.

The conversation left me weeping in the shower, thinking of how there's no one else I know who could make any situation into a party, how she would drag all sorts of people in to become her friends, how she left a mark on everything. I was also sad that there are so many things about our life that I don't remember, but am glad that I have friends to remind me how porous my memory is and how I had forgotten all the details of the summer P spent on bed rest. Will I lose more and more details of her life, and will she disappear bit by bit?

As I stood weeping in the shower, I kept hearing the theme from the Mary Tyler Moore Show in my head.

Stop Drawing.
Start
Watering.

104

Patti's garden is dying.

THINGS are drooping,
BROWN or DEAD,
It's Been a super-hot
summer. AND it's FALL-ish.
But I'm REALLY the one who is to Blame.
I can't look after it,
 I just can't.

Patti loved her garden...

...AND I have
 killed it.

October

I don't want stuff. I lie in bed and think about all of the things we acquired over the decades and I want to purge my life of them. I imagine myself with a suitcase and the clothes on my back and nothing else to weigh me down. I imagine just dumping it all at the curb, all these

things designed for someday, some occasion that'll never arise now. No big family dinner parties to set the table for, no Christmas trees to decorate, no need to read all these books, no rainy days to plan for.

All I have now is me and Jack — who already has a foot out the door to college. All this stuff has lost its meaning and is nothing but dead weight.

I want to be free.

I'm trying to straighten up. It's a mammoth task because as I open every drawer and file cabinet, I find boxes, bags, envelopes, and loose piles of the Detritus of Patti's life. Instead of chucking them, I have to parse them. Why did she want to keep this? What memories Do they dredge up? So I separate the papers into categories of my own: Jack's third-grade stories; records of wheelchair repairs, insurance letters, hospital bills; letters I wrote to Patti on business trips; notes she left by my bedside or stuck into my suitcase; Frank's vet bills; holiday photographs; songs Patti was memorizing so she could perform them at the children's library.

I don't allow myself to feel, just keep my head down and beaver through, sifting wheat from chaff, obsessed with getting through it. But now on Sunday morning, as I sit in bed alone and write this, I can't keep tears from rolling down my face.

All of these documents were the building blocks of the life we had together.

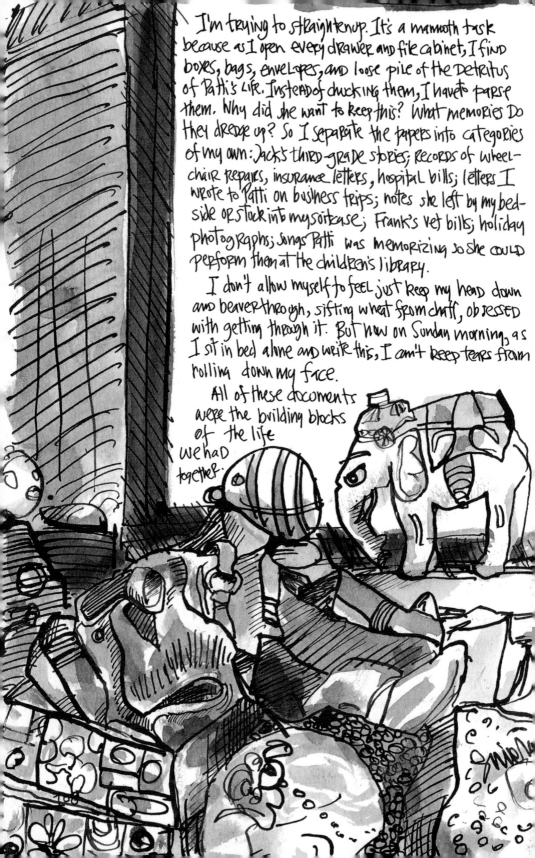

And now I have to arrange them into a monument to what we had. As the pieces separate into categories, they tell stories, stories that I want to keep for myself and for Jack.

And for Patti, because I want so very much for her life to matter. Her last fifteen years were so much harder than they should have been, full of challenges and indignities and pain, difficulties that a sweet and kind and generous person should not have had to endure.

The river of time keeps flowing past and out to sea, carrying all of life with it. Sometimes I cannot see what is passing until it lies at some distance, but the current is strong and moments vanish around the bend, never to be seen again

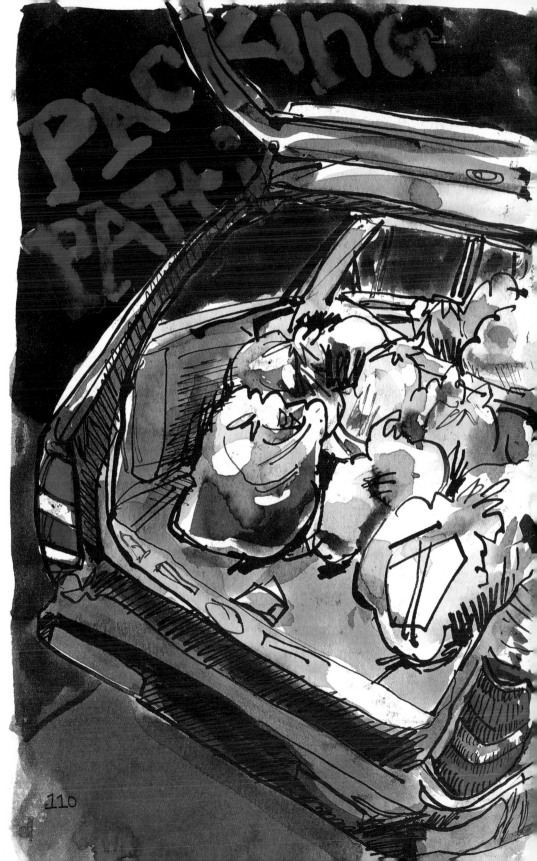

110

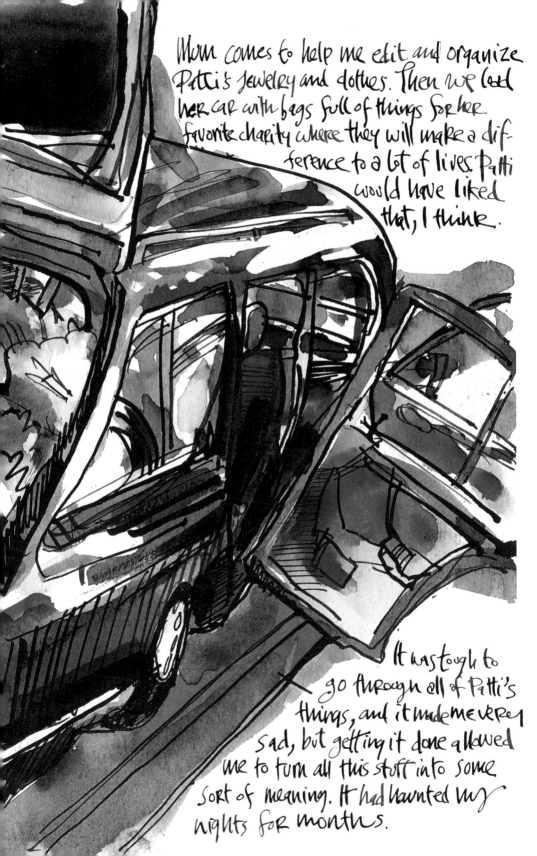

Mom comes to help me edit and organize Patti's jewelry and clothes. Then we load her car with bags full of things for her favorite charity where they will make a difference to a lot of lives. Patti would have liked that, I think.

It was tough to go through all of Patti's things, and it made me very sad, but getting it done allowed me to turn all this stuff into some sort of meaning. It had haunted my nights for months.

Jack said that Patti's
dinosaur

"abandoned hangers look like

bones"

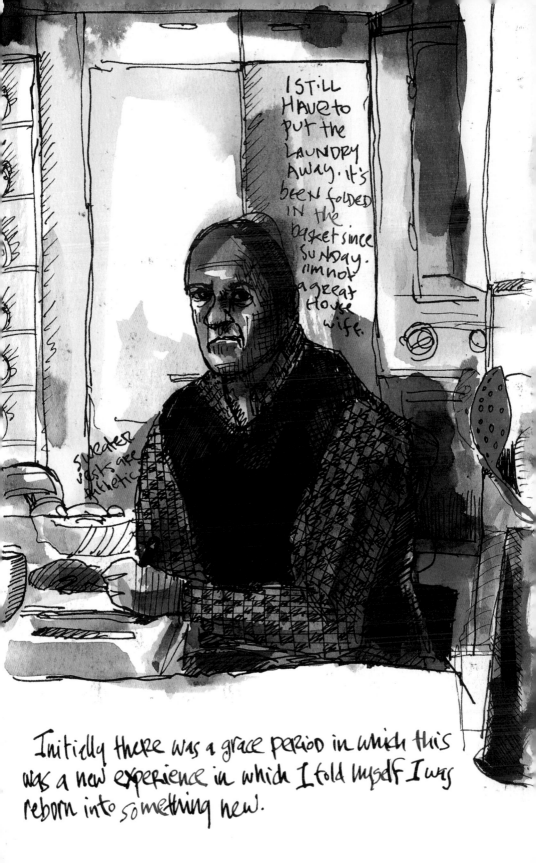

I STILL HAVE to put the LAUNDRY AWAY. It's been folded in the basket since SUNDAY. I'm not a great HOUSE wife.

sweater vests are pathetic

Initially there was a grace period in which this was a new experience in which I told myself I was reborn into something new.

But now when I feel ugliness in me or distortion or a feeling that I am shrunken or distorted, I think that maybe this isn't a phase anymore, it's me changed and damaged, and that I won't go back to being okay, that I won't spring back into shape like a dented sheet of metal.

Am I like a cancer survivor who will go through what's left breastless, wiser and okay? I feel gelded. Or limbless. Or paraplegic — unable to feel or move some essential part of me.

DON'T LIKE THIS CUP MUCH. LIP IS TOO THICK. LIKE KISSING A DUCK.

TEA COSY (INFRARED REPRESENTATION)

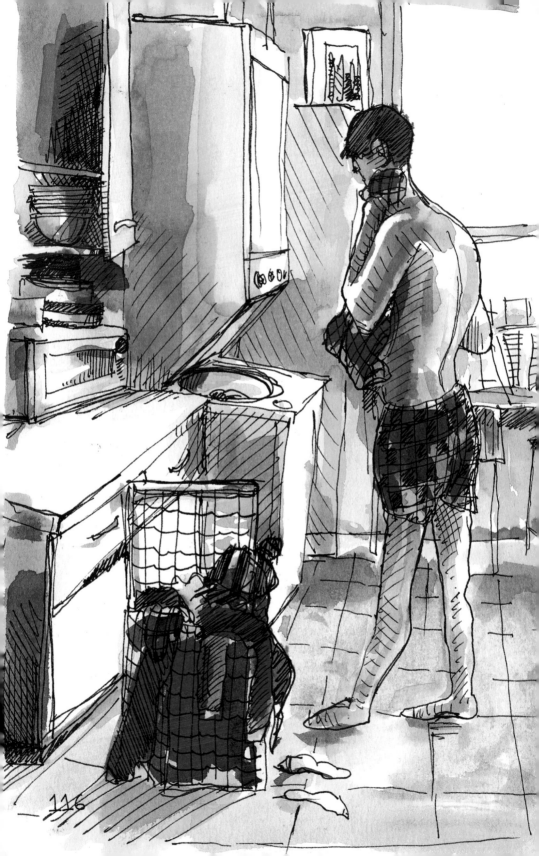

116

Man Up.

I am trying to teach Jack some of the basic skills that he'll need to be an adult human.

Things like:

- how to polish shoes.
 - how to iron a shirt.
 - how to make a bed.
 - how to dress when it's very cold.
- how to make a sandwich.
- how to throw away an empty orange juice container (instead of putting it back in the fridge).

I am trying to make these lessons interesting and fun and not to be too much of an old bastard about it.

Looking back through old photo albums, I am more drawn to the pictures of Patti and me when we were young. Dressing up for parties, dinner with friends, decorating our first apartment, weekend getaways, driving our old '62 Mercury, our old dog Frank when he was still a pup, playing with Jack when he still had long, golden curls. Somehow, that's the spirit that is growing in my heart, the image of Patti when we first met, before the accident, when we were still free to focus on each other and nothing else.

The daily Patti has been replaced by the universal Patti and I think of all the different ways I loved her, at all the different parts of our lives. Every day I feel a change in my perception.

Patti is no longer about her death—she is about her life.

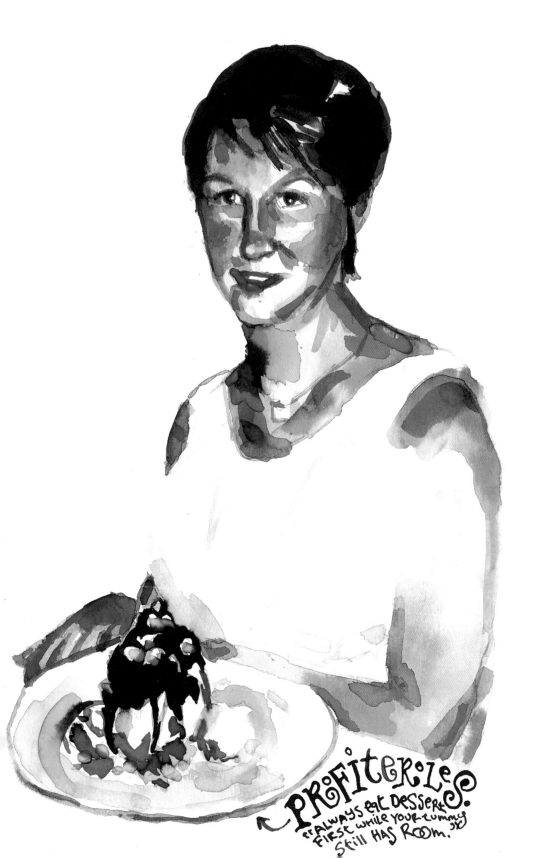

PROFITEROLES
ALWAYS EAT DESSERT
FIRST WHILE YOUR TUMMY
STILL HAS ROOM.

MaRch

P: the bulbs you planted
are coming up again.
I can't always remember
to water them but
someone's making it
rain a lot instead.

Is it you?

A year has gone by, but I have no sense of time. She was just here yesterday, she has been gone for a million years. I had the fantasy that I would come home and Patti would be here in the living room, saying she just wanted to give me a break and that now she was back. I came home and the living room was empty. It wasn't even a real fantasy, just an academic exercise. What would that be like? What would I do or say? But I know I am teasing myself and I don't even delve into the feeling, don't even try to wonder how I would react. A year ago, they told me it would take a year to get over it. Now I know — there is no getting over it. Ever. That I will always be cracked and reglued and that no matter what new chapters I write, there will always be tearstained pages, their ink running. I do not live in a state of sadness, but I know it is just behind the cupboard door. A sweetened sadness but served up from a bottomless well.

Something seems to have clicked in me today. I am sick of it. Sick of the bullshit of my facade, tired of working to hold it together and to keeping on the same road I've travelled my whole life. I need to be freed of these rules and decisions I abide by. I want to make my every remaining minute important and worthwhile. I feel I need to make wholesale changes. I need to follow the directions Patti always gave me and which I too often ignored:

Be free. Be light. Be happy. And still be me.

121

It was one of those running-around dreams, one that came on the heels of a nightful of near nightmares. It culminated in the room where I was supposed to meet up with a group of people. It felt like a Quaker meeting hall or a church, but modern and minimal, filled with light oak pews, many strewn with abandoned coats. I sat down where my group had been seated and I heard her voice. "Daaddannny,"

Then Patti was next to me, her face close to mine in profile. She wore dark glasses, dark hair, a black coat, lots of large white and gold jewelry. I could feel energy coming off her, smell her perfume, feel the wool of her coat collar.

She said, "Danny, when are you going to fall in love?"
I said, "I'm in love with the most beautiful girl in the world."
Still looking straight ahead, she said, "What if someone else can love you more than I can?"
I woke up, my heart hammering.

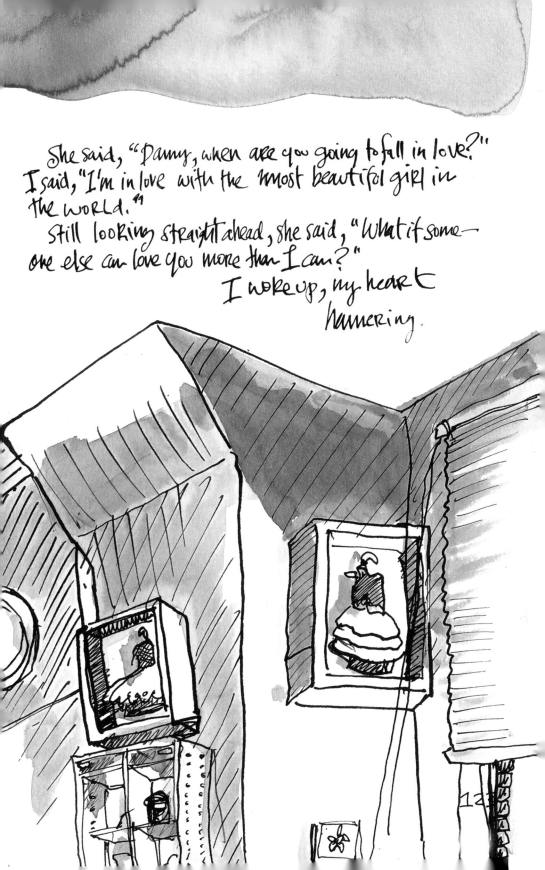

What has become of Jack?

124

He is increasingly creative and self-confident. He has a fashion sense, an imagination, a desire to be a creative person. He tells me that he is more and more inspired to just make stuff. His grades get better, so does his sense of autonomy, of self-sufficiency. He hasn't gotten in trouble, or lost friends, or withdrawn. I don't think he's a big pothead or a binge drinker. He misses his mom. He tells me he thinks about her often, but he is not sad or weepy. He doesn't do all he can to get away from me. He can be crabby and sullen but not at all the way I was at his age. In short, he's like me, he's like Patti, but he's way better.

I think Patti would be so happy with him. My initial attempts to just hold it together and keep things consistent have relaxed, and now I am building a new chapter with him. We are having adventures together, doing our own new things.

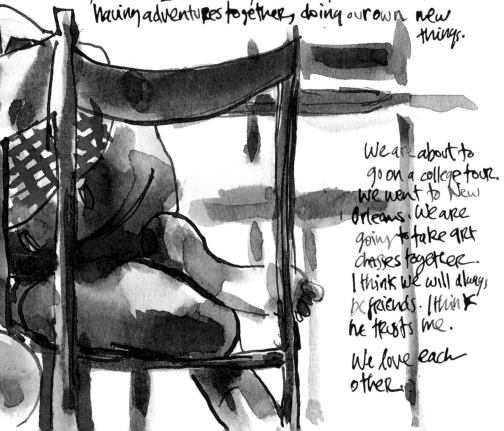

We are about to go on a college tour. We went to New Orleans. We are going to take art classes together. I think we will always be friends. I think he trusts me.

We love each other.

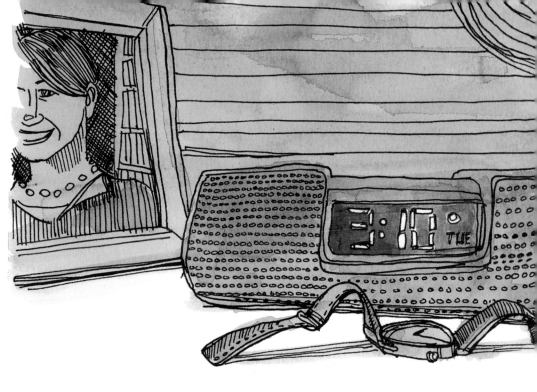

Sometimes when I'd wake up in the middle of the night, Patti beside me, I'd wonder if she was breathing. I'd put my ear close, hear nothing, then nudge her to see if she was still alive. She'd stir and I'd exhale.

Sometimes I'd put my arm around her, feel her by me, and wonder what it would have been like if she hadn't stirred, if she'd gone in her sleep. I'd try on that hollow feeling. But I really had no idea.

A lot of people miss Patti. I do too, of course. But I also miss my life, the way it was— built layer upon layer like a giant oak, habit wrapped around habit, assumption encircling assumption. For nearly a quarter of a century, we built this life and, when Patti's ended, so did mine. My life was like the second twin tower. It collapsed right after the first one fell.

Now I have a different life. It's a pretty good one, despite what I WOULD have thought as I lay with my arm around my sleeping love. It has moments of sadness, deep holes in the road, but it is still filled with love. I love my son, my family, my friends, my hounds. They help me fill those moments of darkness, decide what garbage bags to buy or what to have for dinner. But they can't fill in all the gaps.

127

I'd love to chat on the phone with you as I walk to work, Pat — just once. I'd like you to reach out in the dark and stroke what's left of my hair.

But failing that, I will remember as well as I can what it was like to put my arm around you and I will treasure every day I have left, rather than lying worried in the night.

My new life will be bright. Because you light it.

xxx

DOG

128